"You can't sit around and wait for somebody to say who you are. You need to write it and paint it and do it."

Faith Ringgold

CONTENTS

EDITORIAL TEAM	**2**
NOTE FROM THE PUBLISHER	**4**
INTRODUCTION	**6**

MARK-MAKING 10

Antolina Ortiz Moore 11
Un punto de luz / Light at Dusk

Ana Ruiz Aguirre 19
YEG, Inked

Carlos Andrés Torres 29
*Las pinturas de los hombres jaguar /
The Paintings of the Jaguar-Men*

IMAGE-MAKING 46

Juan Gavasa 47
*Joaquin Sorolla, Aragón y la Jota /
Joaquin Sorolla, Aragon, and the Jota
El pájaro azul cruzó el océano /
The Blue Bird Crossed the Ocean*

Marcelo Donato 73
*El Telón de Picasso /
Picasso's Curtain: A Visual Encounter*

WORLD-MAKING 100

Laury Leite 101
*Museos invisibles /
Invisible Museums*

Liuba González de Armas 125
Shouts on the Wall, Echoes in the Archive

Bettina Pérez Martínez 147
Seascape Poetics

EDITORIAL TEAM

Luciana Erregue-Sacchi

is a Canadian-Argentinian art historian, publisher, and writer, owner of Laberinto Press, Western Canada's press for underrepresented writers and global literature in translation. She is the author of art and literature blog *SpectatorCurator* and recipient of a Joseph Armand Bombardier Canada Graduate Scholarship for completing her Masters in Art History specializing in Argentinian presidential portraiture (University of Alberta, 2016). In 2020 Luciana published her first anthology as editor, *Beyond the Food Court: an Anthology of Literary Cuisines*. Luciana is a Banff Centre Literary Arts Alumni (2019), an Edmonton Arts Council Artist in Residence (2019), and was a recipient of Edmonton Arts Council's Cultural Diversity in the Arts Grant (2020). Her poems and short stories have appeared in Canadian anthologies *Looking Back, Moving Forward* (2018) and *Relatos entrecruzados* (2020) Luciana co-publishes *The Polyglot Multilingual Magazine*, has read at Edmonton LitFest, Edmonton Poetry Festival, The FOLD, and FIL Canada. She has been featured in CBC Edmonton's *Radio Active, EDify Magazine, Quill and Quire, History X* and *An Eloquent Bitch* Podcasts. She lives in Edmonton, AB.

laberintopress.com
spectatorcurator.wordpress.com

Ana Ruiz Aguirre

is a Cuban-Canadian writer and researcher who writes about art through an interdisciplinary and contextual lens. Ana contributed to and co-edited *Beyond the Gallery* with the support of the Edmonton Heritage Council and the Alberta Public Interest Research Group, and she is currently working on her first monograph with the support of the Edmonton Arts Council. Ana's doctoral research examining the strategy and impact of cultural diplomacy in North America was awarded a Joseph Armand Bombardier Canada Graduate Scholarship by the Social Sciences and Humanities Research Council of Canada, and she was a Mitacs Globalink Research Scholar at Universidad Nacional Autónoma de México. Ana was part of the Public Diplomacy and the Economy of Culture Research Group at Queen's University, and has worked at Fondo Cubano de Bienes Culturales, and the Art Gallery of Alberta. She currently serves as Chair of the Fundraising and Advocacy Committee at Latitude 53, one of Canada's oldest artist-run centres.

Liuba González de Armas

is a diasporic Cuban cultural worker. She is both contributor and co-editor to *Beyond the Gallery*. Liuba holds a Bachelor of Arts in the History of Art, Design, and Visual Culture from the University of Alberta and a Master's degree in Art History from McGill University. Her MA research examined representations of women in Cuban revolutionary posters and was supported by a Canada Graduate Scholarship. Her areas of interest include activist printmaking, public art and propaganda, and cultural policy and diplomacy. Liuba has interned and worked at the Smithsonian American Art Museum, the National Museum of American History, the Art Gallery of Alberta, and various artist-run centres across Canada. Most recently, she served as Halifax's Young Curator at the art galleries of Mount Saint Vincent, Dalhousie, and Saint Mary's universities before joining the civil service in Nova Scotia. Liuba approaches visual art of the Americas hemispherically, seeking to foreground spaces of transnational dialogue and solidarity.

NOTE FROM THE PUBLISHER

This is the second anthology from the *Beyond* series by our imprint Laberinto Press. Our aim with this volume is to showcase the talent of some of the best literary professionals in the Hispanic-Canadian community. The purpose behind the *Beyond* series is to engage our readers through the senses. Our first anthology, *Beyond the Food Court*, revolved around the sense of taste, associated with memory, politics, and language. *Beyond the Gallery*, a commentary on our hidden visual canons, requires from our readers seeing with more than our eyesight. The present anthology echoes Laberinto's dual objectives. The first one, the English translation of the texts originally written in Spanish, demonstrates our commitment to the production and dissemination of World literature in translation. The second, offers the readers a web of intersecting and diverging pieces of fiction, creative nonfiction, journalism, and academic research, a labyrinth of visual experiences. We invite you to consider Hispanic-Canadian literature as Canadian Literature, beyond the confines of Magical Realism and the official English-French bilingual model, and to see yourselves in these pages.

Luciana Erregue-Sacchi
Publisher
Laberinto Press

NOTA DE LA EDITORIAL

Esta es la segunda antología de la serie *Más allá,* de nuestra editorial Laberinto Press. Nuestro ánimo es mostrar el talento de algunos de los mejores profesionales en la comunidad literaria hispano-canadiense. El propósito de la serie es comprometer a los lectores a través de los sentidos. Nuestra primera antología *Beyond the Food Court* giraba en torno al sentido del gusto, asociado a los recuerdos, la política, y el lenguaje. *Beyond the Gallery* es un comentario acerca de los cánones visuales ocultos requiriendo de nuestros lectores ir más allá de lo que nuestros ojos nos muestran. La presente antología se hace eco de dos de los objetivos detrás de Laberinto. El primero, la traducción al inglés de los textos escritos originalmente en español demuestra nuestro compromiso con la producción y diseminación de traducción literaria en Canadá. El segundo es ofrecer a los lectores una red de narrativas donde se encuentran y desencuentran las diversas piezas de ficción, crónica, ensayo periodístico y de investigación académica en un laberinto de experiencias visuales. Los invitamos a considerar a la literatura hispano-canadiense como literatura canadiense, más allá de los confinamientos del realismo mágico y del modelo bilingüe inglés-francés como idiomas oficiales, y a verse dentro de estas páginas.

Luciana Erregue-Sacchi
Editora en jefe
Laberinto Press

INTRODUCTION

Brian O'Doherty described the history of modern art as "intimately framed" by the gallery space. He argued that by 1986, when his book *Inside the White Cube* was published following his ground-breaking essays in *Artforum*, we had "reached a point where we see not the art but the *space* first." The exhibition space as described by O'Doherty provides cues to the viewer that legitimize the cultural object as art. Once outside it, he noted, "art can lapse into secular status." [1]

In this anthology, we explore art that exists beyond the exhibition space criticized by O'Doherty, and interrogate how we relate to art unbound from the gallery space. We ask: how do we experience art online? On our skin? On a mountain? During a sporting event?

To answer these questions, this anthology groups essays by eight Hispanic-Canadian authors who write in English and Spanish. As bilingual and diasporic Hispanic-Canadians ourselves and in our role as editors, we wanted the anthology to challenge conceptual constructions of borders (the frame, the wall, the imaginary line between two countries) that define cultural categories both within and without the gallery space, and in doing so, center the views of people who have crossed borders physically and linguistically. We also felt it was important to include both emerging and established writers, as well as writers who primarily create in their mother tongue. We decided to keep the original Spanish texts and to publish them alongside their respective translations in English to remind us of the growing cultural and linguistic diversity of the Canadian population.

There are over 500,000 Spanish-speakers in Canada. In Alberta, we comprise over 60,000 and the number of monolingual English households is declining faster than in any other province. Despite the significant growth of the Spanish-speaking Canadian community, this segment of the population continues to be underrepresented in Canadian Literature, as the publishing infrastructure available to writers creating in languages beyond English and French is nonexistent.

[1] O'Doherty, Brian. 1986. *Inside the White Cube: The Ideology of the Gallery Space.* Santa Monica, San Francisco: The Lapis Press.

Our goal was to create a multilingual and interdisciplinary anthology exploring the intersection of the visual and literary arts. Stepping beyond the institutional confines of art galleries and museums, we invited contributors to reflect on their experiences of the visual, articulating alternative and often underrepresented worldviews. The texts in this anthology address experiences of seeing in different forms.

The first three pieces examine the symbolic and cultural weight of mark-making on substrates that range from ephemeral skies and monumental stone to living human skin. Award-winning Mexican-Canadian writer Antolina Ortiz Moore poetically weaves together skywriting, sculpture, migration, and grief. Canadian-Colombian environmentalist and author Carlos Andrés Torres writes with reverence of his visual encounter with massive pre-colonial murals painted on the stone face of Chiribiquete, the world's largest tropical rainforest national park, now threatened by extractive industries. Cuban-Canadian writer Ana Ruiz Aguirre advocates for the inclusion of tattooing within contemporary gallery spaces.

Contributors address so-called fine and applied visual art objects alike, focusing on their makers' lived experiences, creative processes, and object histories. Spanish journalist Juan Gavasa delves into the connecting stories of celebrated Spanish painter Joaquín Sorolla and graphic designer Francisco Belsué, the largely unknown Spanish immigrant who designed the iconic logo for the Toronto Blue Jays. Argentinian-Canadian multidisciplinary artist Marcelo Donato tells the story of the stage set Pablo Picasso designed and created for Serge Diaghilev's famed *Ballets Russes* in 1917, and its still mysterious sojourn in Buenos Aires during the Second World War.

The last three works explore the world-building potential of images. Mexican-Canadian writer Laury Leite's curious tale of invisible museums playfully challenges boundaries of truth and myth in archival records, reflecting on ongoing dialogues of old and new worlds. Observing the flow of Cuban revolutionary posters to mainland North America since the 1970s, Cuban-born cultural worker Liuba González de Armas explores the afterlives of political images and questions the implications of archival presence and absence. Puerto Rican emerging curator Bettina Pérez Martínez shares her experience of curating from the diaspora in an account of her path to crafting an immersive community-grounded digital exhibition about the contemporary Caribbean in the midst of a global pandemic.

We thank Laberinto Press for entrusting us with this opportunity. As emerging editors and translators, it has been an honor to work with each of the writers and to engage with a broad range of literary practices in Hispanic Canada. Our gratitude to designer Cecilia Salcedo and Spanish language copyeditors Ángel Mota and Carlos Andrés Torres for their work and commitment to excellence. We take earnest pride in the fact that this project was spearheaded and executed by a team of Hispanic-Canadians. We hope to continue building a literary community of multilingual writers and providing content for an audience that has been largely ignored in Canadian literature: Spanish-speaking Canadians.

Ana Ruiz Aguirre & Liuba González de Armas
Editors

MARK-MAKING

10

Antolina Ortiz Moore
Mexico

Antolina Ortiz Moore has been shortlisted for the prestigious Rómulo Gallegos Literary prize in Venezuela (2020), and the Nadal Literary Competition in Spain (oldest literary prize in Spain, and one of the most important in Spanish Literature). Her last novel, *Seda araña* won the First Mexican Woman´s Short Novel Competition in Mexico (2019). Her first and second novels received the José Eufemio Lora y Lora & Juan Carlos Onetti International Award (Peru, 2010). Her first published book derived from her social work thesis at the Universidad Iberoamericana, in Mexico, and was prologued by Elena Poniatowska, selling over fifty thousand copies.

Translation by Kristjanna Grimmelt

Kristjanna Grimmelt is a writer, educator, playwright, researcher, and translator. She is the former editor of the *Peace River Gazette* and former Vice-President for Western Canada of the Literary Translators Association.

Un punto de luz

Los cinco aviones dibujaron cristales en el hielo. Sus alerones iniciaron otro giro sincronizado. El polvo rodó de un lado a otro de la cabina. "Parece ceniza," pensó Lola, "la ceniza de mi esperanza," dijo para sí misma, pensando en los niños.

Su avión estaba en medio de la formación. El cielo abajo, la tierra arriba, el mar como un Jesús en su boca. La estela de condensación fijó su arte efímero en el lienzo de cobalto. La nube se tiñó de malva al atardecer.

De niña, Lola buscó a dios entre las estrellas. Allí estaría su madre también, lo dijeron las tías en el pueblo, en México. "Aunque no la veas, aunque no la escuches," dijeron convencidas. "Son cosas tan pequeñas que no se adivinan, niña, no se sienten. Hay que creerlas." Y Lola buscó en aquel mapa de tesoros. Pero sólo encontró la belleza que sorprende; ese espacio tan amplio en que los planetas son cien veces más grandes que la tierra y sólo parecen un punto de luz en medio de la nada.

Lola se sintió caer. Las alas de los cinco aviones se inclinaban de nuevo, escribieron "Respira" en el cielo. Lola pensó en su padre, en su cuerpo fuerte pero vencido bajo la sábana, en el hospital, ante el transplante. Su corazón en las manos de otro. El médico. Ese brinco. Ese salto al vacío. "Siempre estamos solos," le había dicho esa mañana su padre, sonriendo, cansado. "Siempre estamos solos, Lolita. Aunque a veces nos sentimos acompañados." Ambos cruzaron una frontera esa mañana.

Ahora el sonido quebraba el silencio, los cinco motores, su tinta en el cielo. "Somos," decían, con nubes malva en el lienzo de cobalto. "Cuando la vida se acaba, la vida se acaba," pensó Lola. "¿Entonces, por qué no podemos...?," se preguntó, pensando en los niños, que apenas aparecían como puntos de luz en el atardecer, allá abajo, a lo lejos, en la nada.

El avión enderezó su vuelo, frotó los cristales de hielo al navegar las alturas. La formación le siguió en paralelo; parecía fija en el tiempo, sin moverse. Pero el paisaje se escapaba abajo y detrás de ellos, veloz. Lola soltó los controles un instante y tomó la foto para documentar la obra de arte efímero más vasta que se hubiera hecho hasta ahora. El malestar persistía en su cuerpo. El sol salpicó los cristales. "Somos," decían los reflejos

fragmentados en los fuselajes. "Respiro," paladeó Lola, queriendo saber cómo se siente estar anestesiada, su pecho abierto, la vida en las manos de otros. Impotente. Y dejando de respirar. El sol pegando al cristal.

Lola paladeó las palabras. El vapor escapaba del avión. "Lolita," le había dicho su padre poco antes de morir. "Mi Lolita," soltando el control del avión un instante al hacerlo. "El vacío nos sostiene," le dijo, enseñándole a volar. "Así." Le enseñó. "Así." Su padre, sonriendo, volvía a tomar los controles. "Dolores, te llamas," le había dicho su padre, "porque lo que más amo es también lo que más duele."

Ahora, los niños veían las palabras que los aviones dibujaban arriba. Y allá lejos, como un segundo horizonte, la pared que quería pintar una raya infranqueable sobre la tierra. La cicatriz que no sana sobre la cesárea de un vientre materno, de lo que nos da vida, de lo que nos parió. "Este 'problema' que ahora somos," pensó Lola, "Nuestro corazón en manos de otro, bajo una sábana, esperando el transplante."

Hace mucho, Lola aprendió a nadar en el océano, en lo frío, entre California y Baja California, con su madre. Era como volar en en un cielo pero líquido y helado, entre la risa y las gaviotas. Los aviones comerciales en ese entonces pasaban sobre ellas, tan cerca. La ruta subía hacia el norte. Uno tras de otro, subían. "Allá va tu padre," le decía su madre cada que miraba a uno pasar. Y por las tardes las estelas que dejaban en la atmósfera eran flechas apuntando hacia el norte, hacia el destino que siguió Lola con su padre, cuando su madre murió.

A veces Lola se preguntaba por los pterodáctilos. Encontraron los huesos sobre las dunas, en la playa, poco después de que enterraran a su madre. Los huesos salieron de la tierra a la que su madre entró. Luego entraría su padre. "Y algún día yo," pensó Lola. "¿Habrán dejado estelas, los pterodáctilos?," se preguntó.

Lola dejó de buscar entre las estrellas. Encontró en el arte. Las piedras le enseñaron su devoción material, densa, y pensada como el existir. Primero en el cementerio, junto a las tumbas. Redonda y plana y diferente, cada piedra. Su belleza fue un homenaje a su madre, a su pasar por la tierra. "Son cosas tan pequeñas que sí se adivinan, que sí se sienten," decía Lola. Y una sobre otra, sentada sobre las dunas, las depositó sobre la línea del tiempo. La forma curva adivinaba la presencia ausente

de su madre sobre la arena, una estela de condensación en la atmósfera.

"Los huesos del pterodáctilo en la playa fueron huesos que volaron alguna vez," pensó Lola. Ahora eran huesos junto a huesos, sobre la playa. Lola los colgó de un móvil, bajo el árbol de olivo en la costa, viejo, y torcido. Esa fue su instalación más famosa; el viento meneaba las alas antiguas junto a un mar vacío que se extendía más allá de sí mismo.

Los cinco aviones, esos cinco pterodáctilos con huesos de metal, sobrevolaron la cárcel donde estaban detenidos los niños. Las gotas de condensación escribían palabras. "Respiro" y "Respiras," en nubes. "Abajo, la guerra; aquí el silencio," pensaba Lola. "Tanto, tanto espacio, entre horizonte y horizonte, entre nacer y morir; sólo escucho la voz, la voz: esa voz."

La noche, la luna, su cuerpo, y el mar, y el viento, y los planetas fueron las voces que Lola encontró en el mapa de tesoros. Una piedra, una estrella sobre la playa. Efímera. Círculos concéntricos sobre las dunas. Algo que nunca quiso ser permanente, -pétalos-, pero que tampoco quiso morir. "Porque somos," dice Lola. "¿Entonces, por qué no podemos...?."

La estela de vaho evaporó tras los aviones. Los cinco dibujaron nubes. El ángulo de alabeo cambió nuevamente. El polvo en los zapatos rodó al otro lado de la cabina. Las cenizas brillaron en el sol. Abajo, los miles y miles de niños miraron al cielo. Su esperanza se encontró con la primera estrella, -o más bien un planeta-, cien veces más grande que la tierra. Los aviones inclinaron sus alerones, iniciando el descenso hacia el mar.

Allá lejos, en el horizonte, el de verdad, -el curvo, el sensual, el majestuoso-, podía verse un punto de luz en la nada, una flecha sobre la playa, sobre la cama de hospital, sobre la piedra; esa ave antigua buscando la belleza en todo, buscando lo que sorprende. Esa voz, esa voz; su silencio.

Light at Dusk
Translation by Kristjanna Grimmelt

The five airplanes drew crystals of ice in the atmosphere. Their great wings began another synchronized turn. The dust rolled from one end of the cabin to the other. "Like ash," Lola thought to herself, "the ash of my hope." She thought of the children.

Her airplane was halfway through its formation. The sky below, the land above, the sea like a prayer lost in her throat. The condensation trail fixed her art, ephemeral on the cobalt canvas. The clouds were tinged with mauve at dusk.

As a girl, Lola used to look for god among the stars. Her mother would be there as well, her aunts in the village, in Mexico, had told her so. "Even though you can´t see her," they said, certain of themselves, "even though you can´t hear her. There are things too small to sense, niña, or to touch. You have to have faith." And Lola searched above her, as in a treasure map. But she found only the surprising beauty; that expanse of space where the planets are a hundred times larger than the earth and appear only as light in the void.

Lola felt she was falling. The wings of the five airplanes tilted again, writing "Breathe" in the sky. Lola thought of her father, of his strong but defeated body beneath the sheets, in the hospital, before the transplant. His heart in the hands of another. The doctor. The leap. The jump into space. "We are always alone," her father had told her that morning, smiling, tired. "We are always alone, Lolita. Although sometimes we feel others are with us." Both crossed borders that morning.

Now the sound broke the silence, the five motors, their ink in the sky. "We are," they wrote, mauve clouds on the cobalt canvas. "When life ends, life ends," Lola thought. "So, why can't we…?" The children were light at dusk, down below, far away, in the void.

The airplane straightened out. The formation followed in unison; it seemed stuck in time, motionless. But the countryside slipped by below and behind them, fast. Lola let go of the controls for a moment and took a photo to document the largest ephemeral work of art ever made. The unease persisted in her body. The sun dotted the windows. "We are," said the fragmented glints in the fuselages. "Breathe," Lola savoured,

wanting to know how it felt to be anesthetized, her chest open, her life in the hands of another. Helpless. And to stop breathing. The sun clinging to the window.

Lola savoured the words. The vapour escaped from the airplane. "Lolita," her father had said to her shortly before he died, releasing control of the airplane for a moment as he did, "The void holds us up," he said, teaching her to fly. "Like this." He showed her. "Like this." Her father, smiling, took the controls back. "Your name is Dolores," her father had told her, "because what I love most is also what hurts the most."

Now, the children saw the words the airplanes drew up above. And far off in the distance, like a second horizon, the border wall that sought to draw an impassable line on the earth. A Caesarean scar that doesn't heal on the womb that gave life to us all, that gives birth to us. "This 'problem' that we have become," Lola thought, "our heart in the hands of another, beneath the sheets, waiting for a transplant."

A long time ago, Lola learned to swim in the ocean, in the cold, between California and Baja California with her mother. It was like flying in a liquid, freezing sky, between laughter and seagulls. Back then commercial airplanes passed over them, so close. The route went up north. One after another, they went. "There goes your father," her mother would say each time they saw one go by. And in the afternoons the trails they left in the atmosphere were arrows pointing north, towards the destiny Lola followed with her father, when her mother died.

Sometimes Lola imagined she was a pterodactyl. They found the bones on the dunes, on the beach, soon before they buried her mother. The bones came out of the ground that her mother went into. Then her father. "And one day me," Lola thought. "Did the pterodactyls leave trails in the sky as they flew?" She wondered.

Lola stopped looking for god in the stars. She found art. The stones taught her their material devotion, dense and heavy as existence. First in the cemetery, next to the tombstones. Round and flat, each stone different from the other. Their beauty was an homage to her mother, to her passing through the world. "They are things so small that, in fact, you can sense, you can touch," Lola said, "you have to observe." And sitting on the dunes, she placed them, one on top of the other, in time. The

curved form revealed the missing presence of her mother on the sand, a trail of condensation in the atmosphere.

"The pterodactyl bones on the beach were bones that once flew," Lola thought. Now they were bones next to bones, on the beach. Lola hung them from a mobile, beneath an olive tree on the coast, old and twisted. That was her most famous installation; the wind shook the ancient wings next to an empty sea that spread beyond itself.

The five airplanes, those five pterodactyls with metal bones, flew over the centres where the children were detained. The drops of condensation wrote words. "I breathe" and "You breathe" in clouds. "Below, war; here, silence," Lola thought. "So much, so much space, between horizon and horizon, between birth and death; I only hear the voice, the voice: that voice."

The night, the moon, her body, and the sea, and the wind, and the planets were the voices that Lola found with the treasure map above her. A stone, a star on the beach. Ephemeral. Concentric circles on the dunes. Something that never wanted to be permanent, but did not wish to die—petals. "Because we are"—Lola says—"So, why can't we...?"

The vapour trails evaporated behind the airplanes. The five drew clouds. The roll angle changed again. Dust from the shoes rolled to the other side of the cabin. The ashes shone in the sun. Below, the thousands and thousands of children watched the sky. Their hope could be found with the first star—or rather a planet—a hundred times larger than the earth. The airplanes tilted their great wings, beginning their descent to the sea.

Off in the distance, on the horizon, the real horizon—the curved, the sensual, the majestic horizon—light could be seen in the void, an arrow on the beach, on the hospital bed, on the stones; those ancient birds searching for the beauty in everything, searching for meaning. That voice, that voice, and its silence.

Ana Ruiz Aguirre
Cuba

YEG, Inked

The murder of George Floyd by Minneapolis police officer Derek Chauvin, on May 25, 2020, acted as a catalyst for a dramatic increase in visibility of the Black Lives Matter movement and discussions about representation and inclusion in Canadian media and institutions. Exhibition spaces such as galleries and museums, traditionally controlled by wealthy Anglo-European elites, were not excluded from this conversation as BIPOC artists, cultural workers, and administrators demanded meaningful inclusion. Over a year has passed, and although the conversation continues, those demands for meaningful inclusion and representation have been largely met with token gestures.

The dilution of calls for meaningful actions to promote inclusivity into performative representation is illustrated today, fourteen months after the murder of George Floyd, by the pervasive praxis of reducing representation and inclusion to briging BIPOC bodies into exhibition spaces, largely in short-term and financially precarious roles. Thus far, the inclusion of art media that is not Anglo-European has not even been discussed. The problem with this state of affairs is the expectation that BIPOC artists should produce Anglo-European work in Anglo-European media while neglecting their own culture's preferred media, such as the one explored in this essay: tattooing.

Alberta art historian Nancy Townshend argued in her 2005 book *A History of Art in Alberta 1905-1970*, that "a whole gamut of colonial and imperial interests tried to intercede in the adjudication of artmaking in Alberta."[2] More simply, colonial and imperialist interests had defined the functional conceptualization of art in Alberta: what was art, and what was not. Illustrating the ongoing influence of these interests, her book does not include tattooing as an artistic medium deserving of being chronicled within a history of art in the province, but this is hardly surprising. After all, art institutions in Alberta do not consider tattooing a "legitimate" medium: tattooing is not taught at universities like painting or drawing, and it is not exhibited (and thus legitimized) in authoritative exhibition spaces.

[2] Townshend, Nancy. 2005. *A History of Art in Alberta 1905 - 1970*. Calgary, AB: Bayeux Arts.

But, you may wonder, can tattoos be considered art? And to that I respond: well –why not? A tattoo is essentially a design created on living skin. What makes skin different from canvas? Perhaps its temporality? Or perhaps the ethical difficulties surrounding ownership and display of tattoos prevent contemporary art institutions from recognizing tattoos as art? This suggestion, of course, opens the proverbial can of philosophical worms with questions pertaining to the commodification of art that permeates our contemporaneity; for example: is the value of art determined by how many dollars it sells for at Sotheby's? Indeed, I would not be surprised if there was a generalized reluctance to deal with the implications of attempting to display human subjects in the gallery space, or attempting to sell tattooed skin, whether living or deceased. However, that is certainly not the only option for bringing tattoos into contemporary art exhibition spaces. In 2019, San Francisco's DeYoung Museum displayed a solo exhibition of Ed Hardy's work consisting largely of flash sheets,[3] photographs, and enlarged projections. Therefore, in this juncture, I believe the data firmly suggests that the main barrier for tattoos to enter the white cube[4] in Alberta is the same as the main barrier for BIPOC artists and art administrators to enter it in meaningful ways: the ongoing influence of Anglo-European colonial and racist interests in these spaces.

Throughout the 20th century, the definition of art enforced by Alberta art institutions was limited to Anglo-European visual traditions such as landscape painting, watercolor, oil painting, and tonalism. The first two acquisitions of the Edmonton Museum of the Arts (today the Art Gallery of Alberta) for its permanent collection illustrate this institutionalized preference: Alban J. Cartmell's *Prairie Trails* (1925), a tonally balanced oil painting, and the very similar Robert Gallon's *Welsh Hills*, both gifted to the institution by member-based Anglo-European organizations in Edmonton. Unfortunately, these arbitrary and

[3] A flash sheet is a collection of small tattoo designs which allows the collector to pick an already existing design. They are usually displayed in 11 x14 inch prints, traditionally hand-drawn, and are created predominantly in the American Traditional style.

[4] The "white cube" is an art term regularly used in reference to the hegemonic aesthetic of the contemporary exhibition space, characterised by a square shape, white walls, and light sources placed in the ceiling. The term gained currency after the publication of Brian O'Doherty's book entitled *Inside the White Cube*, where he argued that the reading of art in these spaces was problematic as every object became almost sacred inside it.

hierarchical limitations of what is considered art continue to influence not only museum and gallery programming, but also the curriculum taught to future art professionals in Alberta centres for art learning.

Since tattoos were not recognized as art during the formative years of Alberta's contemporary art institutions in the early 20th century, they continue to be excluded from these spaces today, notwithstanding the fact that Alberta is one of Canada's top-three most-tattooed provinces per capita. Disregarding the growing numbers of tattoo artists and collectors in the province, this artistic practice is still conceptualized by institutions and the available bibliography as a visible manifestation of delinquent tendencies and/or mental health issues. For instance, in February 2011 Marta Gold wrote in the *Edmonton Journal* that Stony Plain Road was "bogged down by a reputation for roughness and an overabundance of pawnshops, cash stores, sex shops and tattoo parlors." This contemporary perspective is heavily influenced by the popular theories of Italian criminologist Cesare Lombroso, who argued during the late 19th and early 20th century that tattoos evidenced a criminal personality. Lombroso validated these claims by collecting images of captured criminals' tattoos as a research method, which in his opinion was sufficient evidence to affirm that criminal tendencies could be divined by studying tattoos.

Lombroso's far-fetched theories gained legitimacy in Europe right around the time the region known as Alberta today was transferred to the Dominion of Canada and First Nations people were confined to reserves while European colonizers took over their land. At the time, Indigenous Peoples utilized tattoos both as visual signifiers of societal rank and as medicine. Inuit and Cree women, for example, received tattoos in their faces, arms, and fingers to embody maturity and belonging, as well as to ward off disease. These tattoos were analyzed by colonizers through Lombroso-influenced lenses, and condemned to be eliminated through cultural genocide alongside nearly every other manifestation of Indigenous culture.

After decades of policies and institutions created to achieve the goal of cultural genocide (including residential schools and the Potlatch Ban), Indigenous tattoos in Canada almost disappeared. Angela Hovak Johnson, creator of the Inuit Tattoo Revitalization Project, wrote that in 2016 it was difficult for her to find an Inuk tattoo artist because nobody had practiced the art since

the early 1900s. This loss was also recorded in a document published by the Glenbow-Alberta Institute in 1972, examining tattoo practices among the Cree, Ojibwa and Assiniboine:

> Many early explorers and travellers reported tattooing to have been common in most areas of North America prior to the breakdown of original native cultures. With the advent of the traders and missionaries, tattooing and many other native practices soon died out. "Only the stubborn and backward," as judged by both white and Indian, retained this older custom.[5]

By the 1940s, Indigenous tattooing practices were almost extinct. An image from Libraries and Archives Canada —notably one of the very few bibliographic materials in that collection referring to tattooing– depicts Paulette Aneroluk and her daughter Eva Kokiloka in St Anne's Hospital. Paulette wears traditional tattoos in her face and arms, and looks at the camera smiling from her hospital bed. Eva, dressed as a nurse and masked, attentively braids her mother's hair. She doesn't have any visible tattoos.

While Indigenous tattooing practices practically disappeared in Alberta during the 20th century, other aesthetics became popular in the province during the tattoo renaissance of the 1960s and 1970s. The City of Edmonton introduced regulatory legislation for tattoo parlors in 1963. This was a step towards legitimizing the practice that could be construed as progressive for the time, given that tattooing was still an illegal activity in cities like New York. The regulation of tattoo shops encouraged more Albertans to get inked, largely with American Traditional flashes and Irezumi-inspired pieces, both aesthetics having gained popularity during WWII.

Edmonton-based artist and tattoo collector Spider Yardley told me during a conversation in September 2018 that he could identify when people got their tattoos because specific aesthetic trends were prevalent in the city during specific times. The 1980s, for instance, were all about the barbed wire arm bands. In the 1990s, large black pieces and celtic-inspired designs were prevalent, and script started gaining currency in the 2000s due, at least in part, to the popularity of actress Angelina Jolie.

[2] Light, D.W. 1972. "Tattooing Practices of the Cree Indians." Calgary, Alta. : Glenbow-Alberta Institute. University of Calgary.

In the 2010s, efforts to recover traditional tattooing practices became more visible in the Canadian art scene, with artists like Angela Hovak Johnson, Amy Malbeuf and Dion Kaszas receiving funding from arts organizations to complete revitalization projects. During that decade, a few tattooing survey exhibitions toured Canadian anthropological museums, but institutions dedicated to the display of contemporary art largely continued to refuse the inclusion of the practice as part of the Anglo-European approved canon.

In Edmonton, tattooing was acknowledged as an artistic practice for the first time in February 2019, when the Art Gallery of Alberta (AGA) opened a solo exhibition by Marigold Santos, an Alberta-based artist with roots in the Philippines who maintains a multidisciplinary practice including painting, drawing, ceramics, and tattooing. Four photographs taken while Santos was tattooing a subject were included in the show, entitled *SURFACE TETHER*, and displayed in a small exhibition space on the second floor of the AGA building in downtown Edmonton. In addition to these photographs, the exhibition space also displayed landscapes painted on canvas and drawings on paper, positioning the tattoo images physically within the sanctioned boundaries of contemporary art. Unfortunately, no other authoritative contemporary art institution in the province has included tattooing in exhibitions before or since, let alone developed an exhibition dedicated to tattooing.

The marginalization of tattooing as an art medium and its consequent exclusion from legitimizing institutions like the contemporary art museum has much to do, as argued by Townshend, with colonization. Cultural theorist Tony Bennett argued in his influential text "The Exhibitionary Complex" that the contemporary exhibition space forms a "complex of disciplinary and power relations" in many ways similar to a prison and other institutionalized forms of social control.[6] In his opinion (and mine) the role of the museum was and continues to be the creation and broadcasting of a historical record which reinforces messages from powerful groups in society. In Alberta, hegemonic Anglo-European groups were deeply invested in cultural supremacy, and therefore, as argued above, sought to

[6] Bennett, Tony. 1996. "The Exhibitionary Complex." In *Thinking About Exhibitions*, edited by Bruce W. Ferguson, Reesa Greenberg, and Sandy Nairne, 58–80. Routledge.

exclusively reproduce Anglo-European art forms and eliminate all Indigenous cultural practices, including tattooing.

These colonial attitudes must be eliminated from exhibition spaces In order to achieve true inclusion and representation. Contemporary art galleries and museums must legitimize all cultural manifestations without shielding themselves in hierarchical and outdated attitudes regarding the value of the work. Tattoos must enter the contemporary art exhibition space. Batá drums must enter the contemporary art exhibition space. Igbo masks must enter the contemporary art exhibition space. Note I said contemporary art exhibition space, not the anthropological museum. These mediums are neither in the past nor a curiosity, nor should they be exhibited as representatives of a specific group of people: the artist must be named.

As for tattooing, it is important to create a record of how the practice is changing and evolving, and of the artists engaging in it. SURFACE TETHER was an important step in the right direction, but it remains an exception to the rule in a largely orthodox provincial art milieu.

PS: I would like to thank the Alberta Public Interest Research Group (APIRG) and the Edmonton Heritage Council for supporting the research and creation of this essay.

Installation view of Marigold Santos SURFACE TETHER, Art Gallery of Alberta, Edmonton, 2019. Courtesy of the Artist. Photo: Art Gallery of Alberta.

Installation view of Marigold Santos SURFACE TETHER, Art Gallery of Alberta, Edmonton, 2019. Courtesy of the Artist. Photo: Art Gallery of Alberta.

Mark Seidel is tattooed by Randy Weklych. Published by the *Edmonton Journal* on November 11, 1976. Material republished with the express permission of: *Edmonton Journal*, a division of Postmedia Network, Inc.

Roy Johnson, Ron and Sharon's Tattooing, finishes work on Ingrid Poss' back. Published by the *Edmonton Journal* on September 26, 1977. Material republished with the express permission of: *Edmonton Journal*, a division of Postmedia Network, Inc.

Carlos Andrés Torres
Colombia

Carlos Andrés Torres (Bogotá, 1976) is a Colombian-Canadian writer specialized in micro-fiction and travel writing. He was the editor of Colombia's Universidad Distrital magazine *INGfórmate*, and taught creative writing for their Professional Engineering program. He is also a contributor to *Mundo Ceri* magazine, also from Universidad Distrital. He has co-authored a volume of interconnected short stories, *A tres manos* (2016) which won the International Latino Book Awards (2018). In 2019 he published his first solo collection of micro-stories, *Ficciones de la vida real*. His stories also appear in the anthologies *Relatos entrecruzados* (Editorial Mapalé) and the tri-lingual volume *Oh! Canadá* (Editorial Artística). His second volume of micro-fiction stories is called *Toques por agudezas* (2021). He is a member of the organizing committee of FIL Canada. A passionate enthusiast of nature photography, and exploring the wilderness, in 2014 he received the recognition of Randonneur Émérite by the Fédération Québécoise de la Marche. Carlos Andrés works as Spanish instructor and professor of Flamenco guitar. He holds graduate degrees in Engineering, International Relations, and Library Sciences.

Translation by Luciana Erregue-Sacchi

Las pinturas de los hombres jaguar

Hace muchos años leí que la belleza de las cosas, más que su utilidad, orienta el alma del hombre hacia los dioses que las crearon. La idea de que lo bello tiende a ser más espiritual que lo útil estremeció mi raciocinio de estudiante de ingeniería de aquel entonces. Sin embargo, la misma frase terminó por avivar mis cavilaciones de artista hasta el punto de desposarme con la escritura, la música y la fotografía de paisaje. Esta suerte de poligamia, con tres cónyuges de cuyo amor sigo siendo esclavo, ha configurado mi alma con letras, sonidos e imágenes que me han revelado la unidad universal de la cual todos provenimos y a la cual indefectiblemente retornaremos. Ha sido en los grandes espacios naturales donde he percibido tal revelación con toda la fuerza y la belleza de sus formas, colores, armonías, significados. Valga decir que allí, el brío de lo bello y lo espiritual, también se ha manifestado útil a mi ser interior. Muchos han sido mis pasos en montañas, ríos, bosques, lagos, desiertos. Muchas las emociones y expresiones místicas. Pero nunca como las de aquella vez cuando fui invitado por aquel sitio sagrado en el centro del orbe en medio de la manigua. Uno de los últimos lugares perdidos de la Tierra, donde solemnes tepuyes han hecho desde siempre el papel de lienzos para conformar una de las galerías de arte más extraordinarias del mundo. Hablo de la Serranía de Chiribiquete, la pinacoteca secreta de los hombres jaguar.

Este parque nacional natural comprende una enorme extensión territorial, más o menos del tamaño de Suiza, que se encuentra en la parte noroeste de la selva amazónica colombiana. Sus más de cuatro millones de hectáreas están dominadas por el fabuloso contraste entre el plano verde arbóreo de la jungla y las grandes formaciones rocosas elevadas, aisladas unas de otras, de pendiente vertical y cima relativamente plana. Son conocidas como tepuyes, las montañas de la selva que se erigen como deidades protectoras cubiertas de fronda y magia salvaje. Chiribiquete posee además una exuberante variedad de hábitats y condiciones climáticas que hacen posible el desarrollo de todos los procesos ecológicos y evolutivos de la flora y fauna presente. La confluencia de especies andinas y selváticas en la zona de las fronteras biogeográficas del parque ha posibilitado además la aparición y el desarrollo de una cantidad notable de nuevas especies de mariposas, peces, aves, anfibios, reptiles y más de un centenar de plantas. Esta mega reserva es por ello uno de los lugares con más alta diversidad

biológica del planeta. Su configuración intrínseca, tan dinámica como sostenible, escapa a ser comprendida en su totalidad mediante los parámetros efímeros y egoístas del hombre civilizado. Para corroborarlo basta una visita.

La nuestra inició cuando el antiguo DC-3 despegó de la ciudad de Villavicencio. Volar en uno de estos aparatos emblemáticos de la aviación moderna es todo un privilegio. Después de su aparición hace ya casi un siglo, estos aviones legendarios continúan surcando los aires en no pocas partes del globo. Aunque muchos se encuentran confinados en hangares de residuos, todavía hay un número considerable en servicio a la espera de su condena a morir desde los aires más remotos. Andrés Hurtado García, mi maestro y compañero de viaje, los describe como águilas adultas que mueren luchando cuando se cansan de volar. En la selva amazónica casi todos han caído y la suma de todos esos accidentes constituye hoy un compendio mítico de la aviación local. Antes de que abordáramos alguien preguntó: "¿Para dónde va ese avión?" refiriéndose al nuestro y la respuesta espontánea de uno de los operadores fue: "¡Para donde caiga."

Dos horas después, y luego de sobrevolar una parte del inmenso cañón natural del río Caquetá que colinda con el aeropuerto, aterrizamos —¡no caímos, por fortuna!— en la población de Araracuara. Allí nos recibió el reconocido biólogo Patricio von Hildebrand, uno de los tres pilares en lo que se refiere a la exploración de Chiribiquete. Los otros dos —con quienes nos encontraríamos en ulteriores viajes a la zona— son su hermano Martin y el antropólogo Carlos Castaño Uribe a quien se le deben los descubrimientos y los estudios más concienzudos sobre las pinturas de los hombres jaguar.

Gracias a sus trabajos de investigación se sabe que Chiribiquete es un vocablo de origen karijona que se puede traducir como "la maloka del ejambre solar." El origen de esta denominación tiene una profunda base espiritual que alude a la manera de alcanzar niveles de sabiduría superior. Se cuenta dentro de la cosmogonía karijona, que la relación del padre sol con su hija la luna dio como fruto a su hijo el jaguar, quien se convirtió en su representante aquí en la Tierra. El jaguar entonces pasó a ser el animal de mayor relevancia —lo cual es cierto dentro del ámbito ecológico— para el control y el balance entre todos los seres y su entorno. Por tal razón, los hombres imitan su carácter, buscan su esencia y tratan de transformarse en él para acceder al conocimiento pleno que sólo se manifiesta

en otras dimensiones. Dicha transformación sólo puede ser posible mediante la comunión íntima con la naturaleza a través de rituales en los cuales el yagé, el yopo y otras plantas sagradas, hacen que algunos hombres puedan devenir en seres de poder, en hombres jaguar, que desde siempre han plasmado su experiencia en forma de dibujos sobre la roca a manera de conocimiento vivo y sello eterno.

Al día siguiente a nuestra llegada, muy temprano y fieles a nuestra premisa de aprovechar el tiempo al máximo porque, como Thoreau, no podíamos perder el tiempo sin maltratar la eternidad, emprendimos un largo viaje fluvial que nos conduciría hasta el corazón de Chiribiquete. El río Caquetá se transformó en Yarí que a su vez se convirtió en Mesay para luego volverse Cuñaré. Después de varias semanas de navegación, lluvia torrencial, fotografía de ensueño, sol intenso, cruce de raudales y avistamiento de animales fugaces y estrellas diurnas, se nos permitió el acceso al costado sur del parque. Ya no era posible dar vuelta atrás, si es que las circunstancias propias de la aventura nos lo habían hecho pensar. Los dioses del lugar habían hecho pacto con nuestra paciencia y perseverancia. Nosotros ya habíamos cumplido y ellos, fieles a sus preceptos, nos convidaron por fin a su prístina galería.

En Chiribiquete se han encontrado hasta la fecha unos setenta murales que contienen alrededor de setenta mil pinturas indígenas. Es una de las mayores concentraciones de arte rupestre en el mundo. Estos murales están ubicados en los tepuyes a diferentes altitudes respecto al piso. Muchos de ellos están a una altura tal que no es posible acceder sino utilizando técnicas de rápel o de escalada. Tal situación ha desconcertado a los estudiosos del tema quienes aún no logran explicar cómo fue posible hacer unas pinturas tan sofisticadas a esas distancias del suelo y en unos sectores de tan difícil acceso. No es además una casualidad la elección de estos lugares. En algunos de ellos la selección obedeció a la enorme belleza del panorama del bosque amazónico; en otros, la escogencia se hizo en virtud a las características geológicas de los tepuyes puesto que no en todos es posible dibujar sobre la roca. Los lugares elegidos son unas superficies bastante lisas, suceptibles de ser preparadas a través de métodos de percusión y desconchamiento de roca en lajas. Esto con el fin de facilitar el proceso de elaboración de las pinturas y de lograr mantenerlas en el tiempo. Valga decir entonces que el grado de conservación de los paneles pictóricos de Chiribiquete es muy

alto en comparación con otros lugares de pinturas rupestres de esta parte del continente.

Varios días recorrimos unos pocos salones de este museo natural. No hace falta comentar nuestras impresiones frente a las exhibiciones. Aunque las descripciones podrían ser ciertamente válidas, las emociones resultan inefables. Lo místico se vuelve cotidiano y el lenguaje habitual pierde toda su capacidad informativa. Digamos tan solo que admirar cada mural es enfrentarse a su soberanía y transportarse a través de diferentes estadios del tiempo y del espacio. Es un contemplar más allá de lo sensorial que desde natura nos delinea y configura como individuos, tan únicos como similares entre sí, en una suma de individualidades que no son otra cosa que entidades claramente definidas en el universo. Es la puerta de entrada a la armonía con lo demás. La fuerza de cada ideograma, de su mensaje, de su misterio, de su novedad, nos relativiza frente a la vida y nos enseña que todos los seres somos parte de lo mismo. Andrés, ensimismado en cavilantes observaciones frente a las pinturas solo atina a recitar uno de sus retruécanos: "Concede Señor a mis sueños la realidad de la vida y a mi vida la belleza de los sueños." Con seguridad, su petición había sido escuchada.

Las expediciones científicas que se han hecho a Chiribiquete no solo han mostrado la enorme riqueza natural de la que goza, sino que además han puesto en duda las teorías antropológicas más aceptadas acerca del origen del poblamiento americano. Las pinturas de los hombres jaguar muestran el dato más antiguo de asentamiento humano en América. Se han hecho estudios que han arrojado fechas tempranas de ocupación humana, evidencia de un poblamiento anterior a lo aceptado por la academia. Eso ha generado bastante polémica porque las fechas que se tenían en poblamiento de la selva amazónica en general rondaban entre los doce mil y diecisiete mil años. En Chiribiquete se ha constatado que hay evidencias pictóricas de hasta veinte mil años, lo cual ha hecho necesario revaluar todo el conocimiento preexistente. Por esta razón, con el aval científico de UNESCO, el parque fue declarado en el año 2018 patrimonio mixto de la humanidad. Su exhuberancia natural junto con su importancia cultural le otorgaron este título.

Gracias a estudios pictóricos comparativos, a varios registros de crónicas antiguas en su mayoría de Phillip von Hutten y a lo poco que se ha podido obtener por tradición oral, se sabe que las pinturas sobre la roca fueron hechas por comunidades

nómadas provenientes de varias partes del continente. Chamanes venidos desde cada rincón dejaron plasmado todo un lenguaje codificado de carácter simbólico y espiritual, que explica el origen de los elementos y de los momentos de origen en el que ellos consideraban el lugar de origen. Al estar localizado sobre la línea del Ecuador, Chiribiquete coincide con la mitad del mundo y se considera el lugar del principio y de la creación. Los hombres jaguar han peregrinado a Chiribiquete para plasmar sus visiones y su cotidianidad en pinturas, desde antes de la aparición de la agricultura. Debieron haber sido recolectores, pescadores, nómadas pues, todo esto ha sido dibujado en la roca, exhibido en sus pinturas que lo dicen todo: muestran andamios con personas pintando, hamacas con hombres descansando, jóvenes como aprendices de chamanes, el jaguar en su barca mágica volando hacia el cielo, los chamanes y sus viajes cósmicos y todo un universo ritual que se extiende a lo largo de milenios. Si en Egipto hablamos de veintisiete siglos, Chiribiquete presenta evidencia de doscientos siglos. Como no hay prueba de que este fuera un lugar de vivienda o de asentamiento temporal, el único uso era ritual. Luego la ritualidad tiene que ser demasiado poderosa para que se haya mantenido hasta hoy después de tanto tiempo. Y digo hasta hoy porque existen registros de pinturas rupestres elaboradas en los años setenta del siglo veinte.

Nuestra estancia total duró casi dos meses. No obstante, la visita a la galería de los hombres jaguar no fue tan larga como queríamos porque la rutinaria civilización ya nos empezaba a llamar de vuelta. Aunque debemos permanecer en ella, nosotros no le pertenecemos. Nuestro devenir es mucho más cercano a los grandes espacios naturales. Chiribiquete es uno de los de más alto rango en nuestro corazón nómada. Y aunque todo en este parque natural puede parecer colmado de perfección, la realidad actual es bien diferente. Varias historias que nos contaron algunos guías y lo que vimos de vuelta desde el aire nos dejaron un mal presagio sobre el futuro de las pinturas. El acercamiento cada vez más frecuente del hombre blanco las tiene amenazadas. Para él la selva representa el infierno verde, una vorágine. Para los hombres de las pinturas es un mundo que habla y se lee cotidianamente. El canto de un pájaro indica la distancia al manantial; la presencia de una flor muestra la fecha; el canto de una rana, la hora; los hombres comen frutas y dejan caer las semillas, de las cuales brotan árboles frutales que luego se vuelven caminos. Pero para el hombre blanco, decía, es un espacio a veces desaprovechado, indeseable tal como es, solo importante en función de su

naturaleza productiva. Es una enorme extensión territorial con potencial económico, cuyo valor seduce su necesidad financiera. La deforestación, la tala ilegal, los incendios y el tráfico ilegal de todo lo que pueda ser traficado amenazan hoy con llegar a las pinturas de los hombres jaguar y sentenciarlas a un destino económicamente viable o a la destrucción.

Aún hoy se han mantenido ocultas de la mejor manera: a la vista de todos. De su importancia apenas empezamos a percatarnos. De su belleza unos pocos hemos tenido la fortuna de deleitarnos y ser conducidos un tanto más arriba en el espíritu. De su utilidad solo los hombres jaguar han dado perfecta cuenta. De su eternidad solo el hombre blanco, como siempre, tendría la capacidad de destruirla en un instante. Sin embargo, cambio mi pensar y me rehúso a creer en su desaparición. El arte es largo y la vida de los hombres es breve. Así ha sido y así será. El arte que sobre la roca es el originario, el primigenio, el arte del génesis que permitió al hombre transformarse en la medida de su pensamiento libre. Tal vez por ello fue que Picasso dijo alguna vez que después de Altamira todo el arte es decadencia; no me cabe duda de que si hubiera conocido las pinturas de los hombres jaguar en Chiribiquete se habría suicidado.

The Paintings of the Jaguar-Men
Translation by Luciana Erregue-Sacchi

Years ago I read that it was beauty, not usefulness, that directed the soul of man towards the gods that had created all things. As a young student of engineering this idea shook my understanding. That same phrase, however, ended up illuminating my artistic preoccupations, to the point of uniting me with writing, music, and landscape photography. This sort of polygamous arrangement, has made me a slave to my love for them. This love has shaped my soul with words, sounds, and images revealing to me the unity of the universe from where we all originate and where we will inexorably return.

It has been in the great natural spaces where I have experienced such a revelation, with all the force and beauty of forms, colours, harmonies, meanings. The joy of the beautiful and the spiritual has manifested as something useful to my inner self. Many are the mountains, rivers, forests, lakes, deserts I have trudged. Many are the emotions and mystical expressions. Nothing can be compared to that time I was invited to a sacred site, situated in the centre of the world in the middle of the jungle. One of the remaining places on earth, where secluded, solemn plateaus called tepuis, have from time immemorial transformed into canvases. I am talking about one of the most extraordinary art galleries in the world, the Serranía of Chiribiquete, the secret gallery of the Jaguar-men.

This national park comprises an enormous territory closer in surface area to Switzerland. It is located in the Northwestern part of the Colombian Amazonian jungle. The park of more than four million hectares, is dominated by the fabulous contrast between the green arboreal canopy and the great rock formations at elevated altitudes, isolated from one another, in vertical slopes and relatively flat cusps. These elevations are known by the name of tepuis, erect as if they were protective deities, covered in fruits and magic wilderness. Chiribiquete also houses an exuberant variety of habitats and climate conditions, making possible the development of all of the ecological and evolutionary processes of their flora and fauna. The convergence of Andean and jungle species in the park's biogeographic borders have also contributed to the emergence and development of a notable number of new species of butterflies, fish, birds, amphibians, reptiles and more than a hundred varieties of plants. That richness makes

this mega reserve one of the most biologically diverse spots on the planet. Its intrinsic configuration, its strange orography, its ecological complicity, as dynamic as sustainable escapes comprehension within the day-to-day, limited parameters of civilized man. Perhaps that is why the great Amazon explorer Richard Evans Schultes described the area as "The workshop of God," the place where the Creator might have conducted the first tentative experiment leading up to the origin of the world. Just one visit is enough to confirm Schulte's opinion.

Ours began once the ancient DC-3 took off from the city of Villavicencio. Flying in one of those aircrafts, emblems of modern aviation is quite the privilege. Even after almost a century, these legendary planes are still crisscrossing the air in a few parts of the world. Andrés Hurtado García, my mentor and companion during this trip, describes them as adult eagles who die fighting as they fly. Although many of them are warehoused in hangars full of debris, there remains a considerable number still in service, in the certainty they will fall sooner or later from the most remote skies. Almost all of the DC-3 flying over the Amazon jungle have crashed, and the sum of all those accidents has become a mythical compendium in local aviation circles. Before boarding our flight someone asked "Where is this plane heading?" to which one of the operators spontaneously retorted "Wherever it falls!."

Two hours after flying over the immense natural canyon of the Caquetá River, next to the airport, we landed in the town of Araracuara —we did not fall by sheer luck!— There, was renowned biologist Patricio von Hildebrand, one of the three main names behind the exploration of Chiribiquete. The other two —whom we would meet in later trips— were his brother Martín and anthropologist Carlos Castaño Uribe, whom we owe the most conscientious findings and studies on the paintings of the Jaguar-men.

Thanks to their work, we know that Chiribiquete is a term original to the Karijona[7] peoples, that can be translated as "The maloca (hive) of the solar swarm."[8] The origin of the

[7] Community that inhabited the area of this natural parkland until the early 20th century, before its decimation due to the extraction of rubber, and conflict with other nearby communities. At present some descendants still survive, after having settled amongst other ethnic groups.
[8] The maloca is an ancestral dwelling of the Indigenous peoples of the Amazon. Although it has mostly a social and ritual function, it is also considered a home.

name has a profoundly spiritual origin referring to the path to ultimate wisdom. A story from the cosmogony of the Karijona community, speaks of how from the union of Father Sun and his daughter, the Moon, their son the Jaguar was born. He became their representative here on Earth. The jaguar thus became the most relevant animal in the Karijona's worldview, and the most important to the ecosystem of the area. This feline has played, and still plays a role balancing and controlling the peoples of Chiribiquete and their environment. They copy his traits, seek his essence, and try to become him, to access the ultimate knowledge which manifests in other dimensions. Such transformation can only be achieved by commmuning intimately with nature. Through rituals with local plants like yagé, yopo, and other sacred species, some of the inhabitants aspire to become powerful beings, Jaguar-men. Since the beginning, the Karijonas have depicted this experience in stone drawings, a sort of living knowledge, an eternal mark.

Early on the day after our arrival, we decided to make good use of our time there, because, like Thoreau wrote, we could not waste time without mistreating eternity. We embarked on a journey up the river, which would take us to the very heart of Chiribiquete. The Caquetá River morphed into the Yarí River, which later transformed into the Mesay, to finally become the Cuñaré. After several weeks of navigating, torrential rain, dreamy photography, intense sunshine, crossing streams, sightings of fleeting animals, and daytime stars, we were allowed access to the Southern area of the park. Turning back was not an option, even if the circumstances of our adventure had made us think otherwise. The gods of Chiribiquete had made a pact with our patience and perseverance. We had fulfilled our end, and faithfully having followed their precepts, they finally ushered us into their pristine gallery.

Chiribiquete's murals total seventy to date, containing around seventy thousand paintings with Indigenous motifs. It is one of the largest concentrations of rock art in the world. The murals rest on the rocks at different distances in relation to the base of the tepuis. Many of them were executed at such heights that it is impossible to reach except by rappelling or climbing. This has disconcerted the specialists, who cannot explain to this day how it was possible to create such sophisticated works at such distances from the ground, and in such hard to reach locations. The choice is no mere coincidence. In some cases it obeyed the breathtaking panoramic beauty of the Amazonian forest; in others, the geological characteristics of the tepuis

determined placement, since it is not possible to draw on all of the rock formations. The chosen spots offer fairly flat surfaces, susceptible to priming through percussion and the chiseling of slabs, with the aim of obtaining a flawlessly finished work, and preserving the works over time. That is the reason for the high degree of preservation of the decorated panels of Chiribiquete in comparison to other rock paintings in this part of the continent.

We spent several days visiting some of the exhibition spaces of this natural museum. I would not wish to offer our impressions of these works. Even if the descriptions were accurate, emotions render them impossible to narrate. The mystic becomes part of daily life, and language loses all its descriptive weight. Let's just say that to admire each mural means facing their sovereignty, transporting us to an alternate time and space. It is to observe beyond the sensory delineation of ourselves as individuals, as unique as similar to one another, a sum of entities clearly defined in the map of the universe. To contemplate those works is to open the door to harmony with our surroundings. The force behind each ideogram, their messages, their mystery, their novelty, makes lives relative, teaching us we are all part of the same whole. Andrés, pensive as he contemplated the paintings, only offered one of his retorts: "Lord, give my dreams the tangibility of life, and offer my life the beauty of dreams." Certainly, his request was granted.

The scientific expeditions to Chiribiquete not only have showcased the enormous natural riches of the region, they have also put into question the most widely accepted anthropological theories on the origin of population groups in the Americas. The paintings of the Jaguar-men date from the earliest human settlements in the continent. Several studies have established earlier dates of human habitation, earlier than previously researched. This has generated a fair amount of debates, since the earliest data on population in the Amazonian jungle goes back between twelve and seventeen thousand years ago. In Chiribiquete there is pictorial evidence dating back to twenty thousand years, which has forced scientists to reexamine all prior knowledge on the subject. In 2018, UNESCO declared this park a dual World Heritage Site, due to its sum of natural exuberance and cultural riches.

Thanks to comparative research on the paintings based on several chronicles dating back centuries, like those of Phillip von Hutten, and the few registers obtained through oral tradition, we can infer that the rock paintings were created by

nomad communities from several corners of the American continent. Shamans from different regions left us a codified language of symbolic and spiritual dimensions, explaining the moments and elements where all things originated. The location of Chiribiquete coincides with the exact half of the world, according to them, the site of the beginning, and original creation. The Jaguar-men, like pilgrims, left us their visions and day to day lives in paintings dating before the development of agriculture. They may have been gatherers, fishermen, nomads. All the scenes depicted on the rocks tell us as much: from scaffolds where people paint, to hammocks with men at rest, young shaman apprentices, the jaguar in his magic canoe flying towards the sky, the shamans and their cosmic sojourns, and a universe of rituals extending for millennia. If we speak of Egyptian settlements dating back twenty seven centuries, Chiribiquete offers us two hundred centuries of evidence. Since there is no proof, however, that the place supported permanent or even temporary settlements, all we can surmise is the ritualistic function of the area. Yet, this ritual aspect must have been tremendously powerful to have sustained over time to this day. Yes, there exist registers of rock paintings well into the 1970s of the 20th century.

Our stay lasted almost two months. However, our visit to the gallery of the Jaguar-men was not as long as we had hoped for. The routine of civilization was demanding our return. Although we must remain here, we do not belong to it. Our existence is closer to the great natural spaces. Chiribiquete is one of the highest ranked in our nomad hearts. And even though this natural park may seem perfection itself, the park's current reality is somewhat different. The guides we encountered told us several stories, compounding the sense of foreboding about the future of the paintings we felt as we saw them from the air. The White man is closer than ever, threatening their permanence. The White man sees the jungle as a green representation of Hell, a chasm. For the Jaguar-men, the jungle is a world to be read on the daily, a site of dialogue. Birdsongs indicate the distance to the spring; the presence of flowers, a date; the croaking of a frog, tells time; men eat fruit and they let the seeds fall to the ground from where new fruit trees sprout, which in turn signal paths. For the White man, as I was saying, it is wasted space, undesirable in that state, important as long as it serves the ends of production. Chiribiquete is an enormous territorial extension with an economic potential whose value seduces financial ambitions. Deforestation, illegal tree cutting, fires, and the illegal traffic of all that can

be extracted threatens the paintings of the Jaguar-men, sentencing them to a viable economic future or to their destruction.

Even today they are hidden the best way possible: in plain sight. We are beginning to recognize their importance. Very few of us have been fortunate to witness their beauty and elevate ourselves spiritually. Of their usefulness, only the Jaguar-men have fully known. Of their eternity, only the White man will be capable of altering their destiny in an instant. However, I swiftly change my mind, refusing to believe they will disappear. Art lasts a long time, life is brief. It has been this way, and it will still be. Rock art is the original art, the first considered such, the art of the genesis that allowed humanity to think freely. Perhaps that is why Picasso said once that since Altamira, art has been in decline; I have no doubt had he seen Chiribiquete he would have taken his own life.

43

Tres vistas de un mural en la faz de una meseta de arenisca en el Parque Nacional de Chiribiquete. Cortesía de autor.

Three views of a mural on the face of a sandstone plateau at Chiribiquete National Park. Courtesy of the author.

IMAGE-MAKING

46

Juan Gavasa
Spain

Juan Gavasa was born in Jaca (Spain, 1971), and has resided in Toronto since 2011. Journalist, author, editor and entrepreneur with more than 25 years of professional experience, he has worked in radio and print media. In 1996 Gavasa co-founded the communication and design company Pyrenean Multimedia, developing a prolific career in his country of origin. Through his company´s publishing label, he promoted numerous publications, with considerable success in Spain. He is the author, co-author, and coordinator of more than 20 books on travel, children's literature, history, traditions and customs. His last stories appear in the anthologies *Historias de Montreal* (Ottawa, 2019), *La Cola del Cerdo* (Ottawa, 2017), and *Historias de Toronto* (Ottawa, 2016), which was awarded the International Latino Book Award. He is currently working on his first novel, which will be published in Spain. In Toronto, he manages the PanamericanWorld news agency, co-founded the creative content company XQuadra Media in 2016 and is a founding member of the digital magazine *Lattin Magazine*. He leads storytelling and oral communication workshops for entrepreneurs and students as well.

Translation by Liuba González de Armas

Joaquin Sorolla, Aragón y la Jota

Las regiones de España (también conocida como *Visión de España*) es el nombre del gigantesco mural de 220 metros cuadrados que decora, desde 1926, la Sala Sorolla de la Hispanic Society en Nueva York. Una entidad fundada en 1904 por el multimillonario americano Archer Huntington con el objetivo de difundir la cultura de España y de Portugal en Estados Unidos. El acaudalado mecenas dedicó buena parte de su vida y de su fortuna al conocimiento de la cultura hispana y a la adquisición de miles de libros y obras de arte españolas, que nutrieron los fondos de su biblioteca y museo público.

En 1911, el magnate estadounidense encomendó al pintor español Joaquín Sorolla la decoración de una gran estancia rectangular de la Hispanic Society. Se concibió hacer una serie de paneles que ilustrarían las diferentes regiones españolas a través de las peculiaridades de sus habitantes y paisajes. El resultado fueron 14 murales de tres metros y medio de altura, que plasman escenas cotidianas y folclóricas de Andalucía, Extremadura, Valencia, País Vasco, Navarra, Aragón, Cataluña, Galicia y Castilla-León. Muchos consideran este encargo como la obra magna de Sorolla. Le costó siete años de interminable trabajo, penosos viajes por todo el país y un esfuerzo físico y emocional que le dejó muy mermado. Un año después de concluir el último panel sufrió un ataque cerebral, que resultó en la hemiplejia de la que ya no se recuperaría.

La idea original de Huntington era la de revisar los principales hitos de la historia de España, pero Sorolla le disuadió con el argumento de que una obra de tipo histórico le exigía investigar cuestiones con las que no estaba familiarizado. Sin embargo, pintar una serie de paisajes de las provincias españolas le otorgaría mayor libertad creativa. El artista valenciano tenía claro que deseaba ofrecer una representación de España con lo pintoresco de cada región. "Pero que conste que estoy muy lejos de la españolada," aclaró en una de las múltiples misivas cruzadas con el multimillonario.

Sorolla comenzó a trabajar, inmediatamente después de haber cerrado los detalles del contrato con su mecenas, el 26 de noviembre de 1911, por el que recibiría 150.000 dólares estadounidenses. Primero recopiló documentación escrita y fotográfica, después viajó durante 1912 por todo el país para tomar anotaciones, realizar bocetos y adquirir objetos

característicos de cada región. Desde el primer momento, el artista sabía qué imagen representaría para el panel dedicado a Aragón. "La encarnación máxima y más universal del espíritu aragonés se manifestaba en la jota," había dicho en más de una ocasión. Así que, decidido el argumento del lienzo, eligió el pintoresco pueblo de Ansó, perdido en las montañas del Pirineo, así como el traje ansotano por su exuberante riqueza y colorido.

Casualmente, el primer apunte que realizó Sorolla en cuanto firmó el contrato tuvo que ver precisamente con Ansó. Lo hizo en su recién estrenado estudio madrileño del paseo General Martínez Campos, en el mes de diciembre de 1911. Contrató a dos mujeres ansotanas, que habían ido a Madrid a vender los productos típicos de la región, pidiéndoles que posaran durante dos sesiones. Es un magnífico cuadro de tamaño natural al que llamó: "*Abuela y Nieta. Valle de Ansó*" y del que todavía se conserva una interesante fotografía en la que vemos al pintor ultimando el grandioso lienzo. Ese primer trabajo establece el método de producción que Sorolla seguiría en los años posteriores, al crear los catorce grandes murales: bocetos de tamaño natural, realismo puro en la captación de los elementos básicos y despreocupación por su conclusión.

Pocos meses después de finalizar este primer panel sobre Aragón, el pintor valenciano emprende un trabajo de campo por todo el país. Del 20 al 28 de agosto de 1912 se establece en el valle navarro del Roncal, al norte de España, donde esboza dos grandes estudios bajo el título común de: *Tipos del Roncal*. El pintor aprovechó la celebración de la fiesta en honor a la Virgen del Castillo para captar multitud de elementos y realizar diversos estudios previos, que después utilizaría en la ejecución del mural definitivo dedicado a Navarra. La técnica siempre era la misma: primero dibujaba escenas individuales que después trasladaba a la obra final. En este acopio de documentación se apoyaba también en el trabajo de los fotógrafos que le acompañaban ocasionalmente.

El 20 de agosto, día de la Virgen del Castillo, el fotógrafo de turno fue el jaqués Francisco De las Heras, a quien Sorolla debió haber conocido en Jaca, durante alguna de sus habituales estancias veraniegas. Y es que la vinculación del pintor valenciano con la capital de la Jacetania fue mucho más que casual, como luego podremos comprobar. Dos años después, Sorolla utilizó la instantánea de los integrantes de la Junta del Valle del Roncal accediendo a la ermita con las banderas de

sus respectivas localidades para pintar el mural de Navarra para la Hispanic Society. De aquella jornada de romería en el valle navarro, Francisco De las Heras realizó una valiosa colección de postales de la que apenas se conserva alguna imagen suelta.

El día 24 de agosto el pintor hizo un viaje a Ansó de apenas unas horas. A ese momento pertenece su ensayo: *Tipos aragoneses*, que actualmente se puede contemplar en el Museo Sorolla de Madrid. El artista escribe a su mujer, Clotilde García, una carta desde el valle ansotano en la que le confiesa que "Ansó es admirable para pintar figuras; así es que cuando tenga que hacer estudios para el cuadro de Aragón volveré aquí." Y así lo hizo en el verano de 1914, pero esta vez acompañado de su esposa y de sus tres hijos. A esas alturas, el artista ya sufría los primeros achaques físicos como consecuencia de los numerosos desplazamientos que realizó por todo el país. Las condiciones de estos viajes fueron penosas y los alojamientos infames. A sus 49 años de edad los achaques comenzaron a ser costumbre. El año de 1912 culmina con la creación de veinticinco grandes estudios, innumerables apuntes de menor formato y varios gouaches. El trabajo de recopilación fue fructífero.

Después de un año de trabajo en su estudio madrileño, Sorolla volvió a viajar con la intención de ejecutar, in situ, algunos de los paneles definitivos. En agosto de 1914, llegó a Jaca y se instaló ahí hasta principios del mes de septiembre. La idea del baile como expresión del carácter festivo y vigoroso de los aragoneses es el fundamento del mural que dedicó a la región de Aragón. Y los ansotanos sus protagonistas indiscutibles. La larga estancia de la familia Sorolla pasó prácticamente desapercibida en la prensa local de la época. Sólo un gran acontecimiento social rompió esa discreción: El 17 de septiembre contrajo matrimonio en la catedral de Jaca la hija del pintor, María Clotilde, con el también artista valenciano Francisco Pons. El enlace estaba previsto en Madrid, pero Sorolla obligó a su hija a casarse en Jaca porque no deseaba sufrir nuevos desplazamientos. Estaba absolutamente inmerso en su trabajo y quería plena dedicación. El padre regaló a la hija un cuadro de un paisaje jacetano.

El mes y medio que la familia pasó en Jaca fue de una actividad frenética para el pintor. Con toda la información recopilada en su estancia en el valle de Roncal, en 1912 ejecutó el panel dedicado a Navarra, sin necesidad de salir de la Jacetania. Más complejo fue el proceso de creación de *La jota*. Sorolla pintó diversos bocetos en los que se combinan las figuras agitadas de

unos niños joteros con los perfiles casi estáticos de dos mujeres ansotanas ataviadas con su característica indumentaria. La que tanto había impresionado al pintor en su primer viaje al Pirineo.

Otro estudio preparatorio, titulado simplemente: *Aragón*, mezcla nuevamente a joteros y músicos entonando guitarras y bandurrias con dos mujeres ansotanas, en un intento de contraponer la sobriedad de éstas últimas con el desenfreno de las aguerridas danzas. El fondo elegido es un caudaloso río, en alusión al Ebro, que se pierde en las montañas nevadas que se divisan en el horizonte de la región. Paralelamente Sorolla dibujó numerosos estudios paisajísticos de los alrededores de Jaca que acabó por utilizar en la concepción del panel definitivo.

Para culminarlo, el artista pone de relieve a un grupo de ansotanos que danza de forma vigorosa, mientras en un primer plano un mozo corteja a una muchacha. A juicio de los expertos, a partir de este panel la técnica de Sorolla evoluciona hacia una mayor amplitud de trazo. Las figuras quedan completamente envueltas por los perfiles sinuosos de las montañas del paisaje ansotano, con el que llegan a fundirse los personajes como si las montañas y esos hombres y mujeres estuviesen constituidos de la misma sustancia. El pintor, impresionado por el traje ansotano, descartó los bocetos previos en los que había planteado la incorporación de los típicos baturros (figura principal del folclore de Aragón) y optó por el aspecto casi pétreo de la singular indumentaria de Ansó, cuya huella antropológica se pierde en la noche de los tiempos. Como ocurre en otros murales, el paisaje de fondo no corresponde a la escena plasmada. Se trata en realidad de las estribaciones pirenaicas correspondientes a Jaca y sus alrededores, una opción elegida por el artista tras desechar la idea original de dibujar el perfil de Zaragoza o algún monumento representativo de la tierra.

Según el experto en arte José Luis Díez, ex subdirector del Museo del Prado de Madrid: "Tanto por su original iconografía como por la potente expresividad de su planteamiento plástico, este panel es probablemente uno de los más equilibrados de la serie, a lo que contribuye no poco la sencillez de su composición, en la que el pintor huye de cualquier artificio de juegos de escorzos y perspectivas."

Concluido el trabajo programado, Sorolla abandonó Jaca a mediados del mes de septiembre de 1914 y se dirigió a San Sebastián, donde concibió el panel dedicado al País Vasco. Ya

no volvió a Aragón. En los años siguientes su entrega al encargo de la Hispanic Society es tan absorbente que se convierte en una obsesión perniciosa. En una carta dirigida a su mujer le reconoce que "no debía haberme comprometido con esa obra tan larga y pesada." En 1918 Huntington, tras haberlo visitado en España, dejó escrito en su diario la triste impresión que le había causado su aspecto: "Sorolla no goza de muy buena salud. Está más delgado y débil y me preocupa su estado. Le encuentro decaído en general y muy cansado."

En junio de 1919, Sorolla finalizó el último de sus paneles para la Hispanic Society, aquel dedicado a la pesca del atún en Ayamonte, pueblo situado en la provincia española de Huelva. Sin duda uno de los mejores de toda la serie. Pocas horas después recibió la felicitación personal del rey Alfonso XIII, quien había seguido de cerca todo el proceso de creación y había mediado infructuosamente para que los cuadros se expusieran en España antes de viajar a Nueva York. Un año después, el pintor sufrió un accidente cerebrovascular que le apartaría de sus pinceles para siempre. Murió en 1923, en su casa de Cercedilla, tres años antes de que fuese inaugurada la Sala Sorolla de la Hispanic Society de Nueva York.

La obra completa regresó por primera vez a España en 2007 para ser restaurada y expuesta en diversas ciudades españolas, antes de regresar a Nueva York en 2010. Fue uno de los grandes acontecimientos culturales de la primera década del siglo XXI, en España. En Valencia tuve la oportunidad de enfrentarme, por fin, a esos grandes lienzos sobre los que yo tanto había investigado y escrito; y en especial al de *La jota*, que el pintor dedicó a mi tierra, Aragón. Pese a los estudios, la copiosa documentación y las numerosas fotografías que se conservan de aquella prodigiosa empresa artística, emprendida en los inicios del siglo XX, la magnitud de esos murales sobrecoge al verlos al natural. Como ocurre cuando uno se sitúa frente al Guernica de Picasso. La grandiosidad de la obra y su complejidad técnica provocan un efecto paralizante en el espectador. Sorolla dejó la vida en aquellos trazos gruesos, luminosos y deslumbrantes; pero legó para la posteridad el testimonio visual de un país viejo y agotado, que estaba a punto de desaparecer.

Esa cultura española, cuyos modos y rituales se perdían en la oscura noche de la Edad Media, apenas había sufrido transformaciones durante los siglos. España era pobre, inculta y atrasada a principios del siglo XX, como lo había sido

siempre. Alguien escribió que fue un imperio, pero nunca fue un país; es decir, las riquezas de la Conquista se dilapidaron en guerras inútiles, en ambiciones de monarcas incapaces y en la voracidad egoísta de una minoría que amasó fortunas, títulos y poder. Nunca sirvió para construir una identidad de nación o un sentido común de sociedad. Esa vieja España, la que viajó y pintó Sorolla, fue la misma que el dictador Franco recompuso tras el fracaso de la esperanzadora experiencia republicana de 1931 a 1936 y la atroz Guerra Civil culminada con la "paz de los cementerios" en abril de 1939.

Joaquin Sorolla, Aragon, and the Jota[9]
Translation by Liuba González de Armas

The Provinces of Spain (also known as *Vision of Spain*) is the name of a massive 220-square-metre mural that has adorned the Sorolla Room of the Hispanic Society of America in New York since 1926. This organization was founded in 1904 by U.S. American multimillionaire Archer Huntington with the aim of promoting the cultures of Spain and Portugal in the United States. The wealthy patron dedicated a good part of his life and fortune to the study of Spanish culture and to the acquisition of thousands of books and artworks from Spain, which fed the holdings of his library and public museum.

In 1911, the U.S. tycoon commissioned Spanish painter Joaquín Sorolla to decorate a large rectangular hall of the Hispanic Society. The project was conceived as a series of panels that would illustrate the different regions of Spain through the particularities of their peoples and landscapes. The result were fourteen murals, each three-and-a-half metres tall, which capture daily and folkloric scenes of Andalusia, Extremadura, Valencia, the Basque Country, Navarre, Aragon, Catalonia, Galicia, and Castile and León.

Many consider this commission to be Sorolla's magnum opus. It cost him seven years of endless work, arduous travels across the country, and draining physical and emotional strain. A year after completing the last panel, Sorolla suffered a stroke, resulting in hemiplegia from which he never recovered.

Huntington's original vision was to retell key milestones in the history of Spain, but Sorolla dissuaded him by arguing that such historical type of work would require research into matters unfamiliar to him. Nevertheless, painting a series of landscapes of the Spanish provinces would offer him greater creative freedom. The Valencian artist was certain he wanted to offer an image of Spain that highlighted the picturesque character of each region. "But let it be clear that I am removed from the

[9] The jota is a genre of music and associated dance, both originating in Aragon and known throughout Spain.
[10] Translator's note: The term Españolada, often translated as Typically Spanish, is a derogatory term used to describe artistic works which give an exaggerated or stereotyped image of Spanish people, often intended to be consumed by foreigners and especially popular in the 19th century.

Españolada,"[10] he clarified in one of his many written exchanges with the multimillionaire.

Sorolla set to work immediately after confirming the details of the contract with his patron on November 26 1911, for which he would receive 150,000 U.S. dollars. First, he gathered written and photographic documentation. He then travelled across the country throughout 1912 to take notes, make sketches, and acquire objects that were typical of each region. From the beginning, the artist knew what image he would depict on the panel dedicated to the province of Aragon. "The highest and most universal embodiment of the Aragonese spirit manifests in the jota," he said on more than one occasion. Thus, having decided on the panel's content, he chose the picturesque town of Ansó, lost amid the Pyrenees mountain range, as well as the Ansotano costume for its exuberant richness and colour.

Coincidentally, Sorolla's first studies upon signing his contract had to do precisely with Ansó. He made these in his newly-opened Madrid studio on the Paseo General Martínez Campos, in December 1911. He hired two Ansotana women, who had gone to Madrid to sell typical products of their region, asking them to sit for him for two sessions. The result is a magnificent life-size double portrait which he titled *Grandmother and Granddaughter, Valley of Ansó* and of which there remains an interesting photograph that shows the painter adding final touches on the impressive canvas. This first work establishes the production method Sorolla would follow in subsequent years as he made the fourteen large-scale murals: life-size sketches, pure realism in his depiction of basic elements, and lack of concern for their resolution.

Few months after finalizing this first panel about Aragon, the Valencian painter undertook a fieldwork term throughout the country. From August 20th to 28th, 1912, he settled in the Navarrese valley of Roncal, in Northern Spain, where he sketched two large studies, both under the title of *Types of the Roncal*. The painter made use of a celebration in honour of the feast of the Virgen del Castillo to capture a multitude of elements and make studies which he would later use in the definitive mural dedicated to Navarre. The technique remained the same: he began by drawing individual scenes which he would then situate in the final larger work. In this manner of sketching and documenting, he also relied on the work of photographers which occasionally accompanied him.

On August 20th, day of the Virgen del Castillo, the hired photographer was the Jacetano Francisco De las Heras, whom Sorolla must have met in Jaca during one of his frequent summer sojourns in the region. The Valencian painter's link to the capital city of Jacetania was more than incidental, as I will confirm. Two years later, Sorolla would capture an instance where members of the council of the Valley of Roncal entered a chapel with the flags of their respective localities in his mural of Navarre for the Hispanic Society. From that day of romería[11] in the Navarrese valley, Francisco De las Heras created a valuable collection of postcards from which only a few single images remain.

On August 24th, the painter made a trip to Ansó, only a few hours away. His study *Aragonese Types*, which is presently held at the Sorolla Museum in Madrid, corresponds to this moment. The artist writes his wife, Clotilde García, a letter from the Ansó valley in which he confesses "Ansó is a remarkable site for painting figures; so when the time comes to make studies for the Aragon painting, I will return here." And so he did in the summer of 1914, this time accompanied by his wife and three children. At this point, the artist had begun to suffer his earliest afflictions as a result of the numerous trips he made throughout the country. Conditions on these journeys were arduous and the accommodations equally dreadful. At 49 years of age, Sorolla became frequently ill. The year 1912 culminated with the creation of twenty-five large-scale studies, countless smaller sketches and various gouaches. The research undertaking had been fruitful.

After a year of work at his Madrid studio, Sorolla once again sets out to travel with the intention of making, in situ, some of the definitive panels. In August 1914, he arrived in Jaca and settled there until the beginning of September. The notion of dance as the expression of the festive and vigorous character of the Aragonese people is at the heart of the mural he dedicated to the region of Aragon, and the Ansotanos are its indisputable protagonists. The Sorolla family's lengthy stay in Jaca went largely unremarked in the local press of the time. Only one great occurrence broke this discretion: on September 17, the

[11] Translator's note: a romería is a yearly, short-distance Roman Catholic religious pilgrimage practiced in the Iberian Peninsula. The destination is often a sanctuary or hermitage consecrated to a religious figure honored in that day's feast. Besides attending religious services and processions, pilgrims participate in social events like singing, feasting and dancing.

painter's daughter, María Clotilde, married another Valencian artist, Francisco Pons, at the cathedral of Jaca. The engagement had been planned in Madrid, but Sorolla demanded his daughter marry in Jaca, not wishing to subject himself to further travel. He was absolutely immersed in his work and wanted to dedicate himself entirely to it. The father gave the bride a painting of a Jacetano landscape.

The month-and-a-half the family spent in Jaca was one of hectic activity for the painter. With all the information he compiled during his stay in the Roncal valley in 1912, he executed a panel dedicated to Navarre without leaving Jacetania. Even more complex was the process for creating *The Jota*. Sorolla painted various studies combining the frenzied figures of jotero children with the quasi-static profiles of two Ansotana women clad in the characteristic attire which had so impressed the painter on his first trip to the Pyrenees.

The other preparatory sketch, simply titled *Aragon*, once again blends joteros and musicians tuning guitars and bandurrias[12] with two Ansotana women in an attempt to juxtapose the sobriety of the latter with the abandon of the daring regional dances. The chosen background is a wide river, alluding to the Ebro, which fades into the snowy mountains that mark the horizon of the region. Sorolla concurrently drew various landscape studies of the surroundings of Jaca which he ended up using in the composition of the definitive panel.

Lastly, the artist highlights a group of Ansotanos vigorously dancing, while a youth in the foreground courts a young woman. In the opinion of experts, from this panel onwards, Sorolla's technique evolved toward a greater range of strokes. The figures become completely enveloped by the sinuous profiles of the mountains of the ansotano landscape, with which they meld as if the mountains and these men and women were made of the same substance. The painter, impressed with the Ansotano costume, discarded previous sketches where he had proposed to include baturros[13] and opted for the almost stony look of the singular costume of Ansó, whose anthropological origins are lost in the night of time. As in other murals, the landscape in the background does not correspond to the represented

[12] The bandurria is a stringed instrument used in Spanish folk music, and is similar in form to the mandolin.
[13] The baturro is a typical Aragonese peasant farmer, the main folkloric figure of the region.

scene. It depicts instead the Pyrenean foothills of Jaca and its surroundings, a choice made by the artists after rejecting his original idea to draw the contours of Zaragoza or some other representative monument of the region.

According to art expert José Luis Díez, former Deputy Director of the Prado Museum in Madrid: "As much for his original iconography as for the potent expressiveness of his painterly execution, this panel is probably among the most balanced of the series, in no small part due to the simplicity of its composition, where the painter steers clear of any excessive play of foreshortening and perspective."

Once the planned project was completed, Sorolla left Jaca around mid-September of 1914 and went on to San Sebastián, where he conceived the panel dedicated to the Basque Country. He did not return to Aragon. In the years that followed, his dedication to the commission for the Hispanic Society became engrossing to the point of pernicious obsession. In a letter to his wife, the artist recognized [he] "should not have committed to such a long and difficult endeavour." In 1918, Huntington, having visited Sorolla in Spain, left a record in his diary of the sad impression the latters' appearance had given him: "Sorolla's health is not well. He is thinner and frailer, and his state troubles me. I find him generally downcast and very tired."

In June of 1919, Sorolla completed the last of his panels for the Hispanic Society, dedicated to tuna fishing in Ayamonte, a town in the Spanish province of Huelva. There is no doubt it is among the best of the entire series. A few hours later he received a personal message of congratulations from King Alfonso XIII, who had been closely following the entire process of creation and who had unsuccessfully intervened for the works to be exhibited in Spain before travelling to New York. A year later, the painter suffered a sudden cardiovascular incident which would permanently keep him from his paintbrushes. He died in 1923 at his home in Cercedilla, three years after the Sorolla Room was inaugurated at the Hispanic Society in New York.

The full set of works returned to Spain for the first time in 2007 to be restored and exhibited in various Spanish cities before returning to New York in 2010. This was one of the great cultural events of the first decade of the 21st century in Spain. In Valencia, I had the opportunity to encounter, at last, these great canvases which I had so often researched and written about, especially that of *The Jota*, which the painter dedicated

to my homeland, Aragon. Despite the literature, copious documentation and numerous enduring photographs of this prodigious artistic enterprise undertaken at the beginning of the 20th century, the scale of these murals in person overwhelms. Just as when one stands before Picasso's Guernica, the magnificence of the work and its technical complexity have a paralyzing effect on the viewer. Sorolla put life itself in those thick, luminous, and dazzling strokes; but he left for posterity a visual testimony of an old and tired country about to vanish.

That Spanish culture, whose manners and rituals faded in the dark night of the Middle Ages, had hardly undergone any change for centuries. Spain was impoverished, uncultured, and backwards at the beginning of the 20th century, as it had always been. Someone once wrote that Spain had been an empire, but never a country. That is, the riches of the Conquest were squandered in useless wars, on the ambitions of inept monarchs, and on the selfish greed of a minority that hoarded wealth, titles, and power. They never served to build a national identity or a cohesive model of society. This old Spain, in which Sorolla travelled and painted, was the same one dictator Franco restored after the failure of the inspiring republican experience of 1931 to 1936 and the atrocious Civil War ended by "the peace of the cemeteries" in April 1939.

El pájaro azul cruzó el océano

Paco Belsué fue un artista gráfico nacido en Jaca (España), quien en los años 60 del pasado siglo emigró a Canadá, en busca de fortuna y libertad. Paco había construido su universo de influencias y referencias artísticas en la misma catedral románica jacetana en la que tan solo unas décadas antes había contraído matrimonio Clotilde, la hija de Joaquín Sorolla. Aquel templo casi milenario, de formas austeras y luz esquiva, se encumbra como rocoso microcosmos de inspirada y silenciosa introspección. Esa inspiración, educada en el arte sacro, viajó con él a Toronto, donde se transformaría en expresión moderna de grafismo publicitario. Paco, que de niño miraba embelesado las vidrieras de la catedral de Jaca, diseñaría en Canadá, años después, el logotipo del equipo de béisbol de los Blue Jays. Una semejanza con él, que había decidido volar como ese pájaro azul que surca los cielos de Ontario.

La madre de Paco era la mondonguera (la persona que prepara y vende para su consumo los intestinos y otras partes de la vaca o el cerdo) más popular de Jaca y su padre trabajaba en la serrería de Altahoja. Los duros años de la postguerra los pasó entre las aulas de los Escolapios y como monaguillo en las liturgias diarias, en las que se quedaba absorto contemplando el arte sacro, ajeno a las diatribas del sacerdote en turno. Ahí nació su pasión por el diseño, que con el tiempo se convertiría en una fructífera carrera profesional.

Desde niño se vinculó a las actividades religiosas de casi todas las iglesias de Jaca. A los doce años de edad ayudaba a las Madres Benedictinas en la misa y por ello recibía como compensación un pedazo de chocolate, que las monjas le dejaban en el torno del claustro. Una infancia vivida entre retablos y olor a incienso que marcó definitivamente su vocación creativa y su pasión por el arte sacro. Sus primeras creaciones nacieron de las pesetas de oro y plata que le llevaba el padre capuchino Esteban, con el fin de que los transformara en alambre para rosarios.

Eran los años de la escasez y el vivir de raciones de comida, en una Jaca acongojada por la cercana guerra civil. El ritmo diario lo marcaba la iglesia, el ejército y una burguesía local que se había preocupado en acrecentar las diferencias entre clases sociales. "Un mes de febrero los escolapios nos hicieron subir a los "externos" del colegio, así nos llamaban a los que

no podíamos pagar la matrícula, todos los ladrillos que hacían falta para construir la segunda planta del edificio de la calle mayor. Los que pagaban no lo hicieron, por supuesto," me contó en el verano de 2003, cuando lo conocí en su modesta casa de Greektown, en Toronto.

Poco después empezó a trabajar en la Joyería Muñoz como aprendiz y más tarde en la librería El Siglo. Un día llegó Víctor Sarriá, un viajero que comercializaba las postales Victoria. Le ofreció un trabajo en Zaragoza y 300 pesetas de sueldo. Así comenzó la etapa zaragozana y su labor definitiva en el diseño. Enseñó dibujo en las Escuelas Pías y estudió en la Escuela de Artes y Oficios, con los profesores Félix Burriel y Luis Berdejo, aunque siempre se ha definido como "un autodidacta en todo. Fui profesor sin acabar el bachillerato, mi único título es el de Maestro Artesano, aunque lo considero una anécdota," me confesó en aquel encuentro.

La calidad de su arte le permitió entrar como diseñador en los afamados Talleres Quintana, especializados en orfebrería religiosa. Fue la culminación de un sueño tan anhelado. Tiempo atrás había prometido diseñar un manto para Santa Orosia, la patrona de Jaca, si conseguía el trabajo. Lo hizo en 1958 y hoy se sigue exponiendo cada 25 de junio coincidiendo con la fiesta de la patrona de la ciudad. De este modo, Paco siguió los pasos de su hermano Santiago, quien ya se había convertido en un reputado encuadernador y restaurador de libros.

Entre 1956 y 1957 trabajó intensamente en las reformas del camarín de la Virgen del Pilar de Zaragoza y en el diseño de la corona que se coloca en la ofrenda de flores. Suyas son también las vidrieras, sagrarios y comulgatorios de la iglesia del pequeño pueblo de Caldearenas, en el Pirineo aragonés. La impronta religiosa está presente en esos primeros trabajos de forma palmaria y comprueba hasta qué punto ha sido rentable su infancia entre curas y retablos, "conocía la iconografía religiosa a la perfección y pude trabajar desde muy joven adaptando sus interpretaciones a mi gusto."

El cierre de Talleres Quintana le obligó a especializarse en publicidad y artes gráficas. Combinó este tipo de trabajo, hecho en varias agencias, con la formación artística que recibe en compañía de Natalio Bayo, Juan Tudela y José Luis López Velilla, en el estudio de pintura de Alejandro Cañada. De esta forma, la orfebrería y la cristalería fueron la antesala a los anuncios publicitarios de Pikolín, Konga o La Pitusa, populares bebidas

refrescantes de la época. Con ello, en Zaragoza, una generación pionera de excelentes dibujantes se formó, de manera autodidacta, en las artes del diseño publicitario. Francisco Belsué es uno de sus principales ejemplos, pero el destino le señaló la lejana Canadá.

Su amigo Juan Tudela había recibido una carta en la que pedían dibujantes españoles —cotizadísimos en ese entonces en todas las agencias publicitarias—, para trabajar en una película de dibujos animados. Ellos eran unos privilegiados en aquella España plomiza y triste que se desperezaba con el desarrollismo industrial y los primeros turistas. Belsué, quien diseñaba en la agencia zaragozana e imaginaba otros mundos sin dictadores, decidió atender aquella llamada de la prosperidad y establecerse en un remoto país, el cual no era un receptor habitual de la emigración española.

Comenzó a trabajar en la agencia Savage Sloan Ltd, de la que tiempo después recibiría el encargo de diseñar el logotipo del equipo de béisbol profesional, recién creado, de los Blue Jays de Toronto. Era el año de 1977. El ambicioso proyecto fue a parar a la mesa de trabajo de Paco. Tenía que jugar con la imagen de la chara azul, un pájaro popular de color azul, blanco y gris que abunda en toda la zona noreste de Norteamérica. Tras descartar unos cuantos bocetos, dio con el definitivo; una combinación previsible pero eficaz del pájaro de marras, una pelota de béisbol y la hoja de arce, cómodo recurso para el toque patriótico. Así de sus manos y de su imaginación surgió el diseño del que con el tiempo se convertiría en uno de los logotipos más famosos y rentables de Canadá.

El trabajo fue firmado por la agencia y con ello la creatividad de Paco Belsué permaneció en el anonimato. En cuanto al logo, tan solo en la primera semana su comercialización generó diez millones de dólares de beneficios, pero Paco sólo cobró su cheque semanal, sin recibir regalía alguna. Fue el artista anónimo de uno de los logotipos más populares del país. En el libro *This Side of Spain,* editado en los años 80, se relata la actividad de la colonia española en Canadá. En uno de los apuntes, el autor pide que la contribución de Belsué "a Ontario y Canadá ocupe un lugar en la historia del país."

Hay que vivir en Toronto para entender la dimensión que tienen los Blue Jays entre sus habitantes, cómo está presente en la vida diaria, a la altura del de los Maple Leafs y el de los Raptors. Cuando con la primavera comienza la temporada de béisbol, la

imagen creada por Paco Belsué se incrusta en toda la ciudad y en todos los objetos de consumo cotidiano. Los Blue Jays son el único equipo no estadounidense que ha ganado las Series Mundiales. Lo hicieron en dos ocasiones consecutivas, en 1993 y 1994. Hito que aparece en los libros de historia del país, con letras de forja. El Rogers Center, el formidable estadio en el que juegan, constituye, junto a la CN Tower, los dos íconos más emblemáticos de la vista panorámica de Toronto.

Desde que Paco diseñó aquel primer logo, los Blue Jays lo han modificado para adaptarlo a las tendencias de diseño de cada época y con ello acoplarse a las tendencias de la mercadotecnia. Sin embargo, los aficionados reivindicaron siempre el diseño original, comprando las camisetas y las gorras con su estampa. Así es que el club decidió, hace algunas temporadas, recuperarlo definitivamente y olvidarse de experimentos.

El diseñador aragonés creó otros trabajos para firmas tan relevantes como la American Express o la Benson & Hedges, pero nunca pasó de ser un talentoso, discreto y eficiente diseñador gráfico, que hizo ganar millones de dólares a sus agencias y a sus clientes. En el camino dejó de ser Paco y se convirtió en Frank, aunque sus correos electrónicos siempre los firmaba con un "Paco de Jaca." Sospecho que la vida no lo trató demasiado bien, su carrera profesional, pese a todo, no fue ni exitosa ni deslumbrante. Se prodigó en agencias y en trabajos poco edificantes. Con esto, su creatividad y producción se fueron consumiendo lánguidamente.

Lo conocí en 2003, durante la etapa postrera de su vida, cuando, ya jubilado, residía en un adosado de dos plantas en el populoso barrio de "Greektown," al sur de Toronto. La entrada de su casa estaba presidida por un gran cuadro suyo de la peña Oroel; la montaña de Jaca, y de otros bocetos sobre pintorescos rincones españoles grabados en su memoria infantil. Hay modestias que duelen y otras dignifican; la que vestía su casa era de las últimas.

En esa ocasión, hablamos mucho de nuestro pueblo, el cual él había abandonado medio siglo antes y sobre el que yo pregonaba ahora como un heraldo de buenas nuevas. Las suyas eran memorias vibrantes y fértiles de una vida que se precipitaba al desenlace después de despojarse de toda la fruslería. Escribí un artículo sobre nuestro encuentro para una revista española y nunca más nos volvimos a ver. Él me enviaba de vez en cuando, cada vez más espaciados, correos con ocurrencias, diseños o

enlaces a páginas en las que se documentaba alguna conjura mundial. Creo que lo que le dio vida en sus últimos años fue la constatación de que había que estar alerta ante todas las conspiraciones que se construían a nuestro alrededor para dominar el mundo.

Pocas semanas después de instalarme en Toronto, en octubre de 2011, uno de sus sobrinos me escribió para decirme que Paco acababa de morir. Quiero pensar que el destino obró de esa manera nada caprichosa, con determinismo; se iba ahora que ya había llegado a Toronto otro jacetano para tomarle el relevo.

The Blue Bird Crossed the Ocean
Translation by Liuba González de Armas

Paco Belsué was a graphic artist born in Jaca, Spain, who emigrated to Canada in the 1960s in search of fortune and freedom. Paco had built his universe of artistic influences and references in the same Romanesque Jaca cathedral in which only a few decades earlier Clotilde, daughter of Joaquín Sorolla, had wedded. That nearly thousand-year-old temple, with its austere forms and elusive light, extols itself as a rocky microcosm of inspired quiet introspection. Such inspiration, trained in eclesiastic art, travelled with the artist to Toronto, where it would transform into a modern expression of commercial graphic design. Paco, who as a child was enraptured by the stained glass windows of the cathedral of Jaca, would years later design the logo of the Blue Jays baseball team in Canada. As if by analogy, the artist decided to fly like the blue bird that sails through the skies of Ontario.

Paco's mother was the most popular mondonguera[14] in Jaca, and his father worked in the Altahoja sawmill. He spent the difficult postwar years between the classrooms of the Piarists monks and as an altar boy on daily liturgies, during which he became engrossed in eclesiastic art, oblivious to the diatribes of the priest on duty. There emerged his passion for design, which would over time lead to a fruitful professional career.

From an early age he became involved in religious activities in almost all churches in Jaca. At the age of twelve, he helped the Benedictine Mothers for Mass and received, as compensation, a piece of chocolate that the nuns left him by the cloister. A childhood lived among altarpieces and the smell of incense definitively marked Belsué's creative vocation and passion for eclesiastic art. His earliest creations were born of the gold and silver coins he received from Capuchin Father Esteban, to be converted into wire for rosaries.

These were years of scarcity and rationed food, in a Jaca anguished by the impending civil war. The daily rhythm of life was marked by the Church, the Army, and a local bourgeoisie concerned with expanding the gap between social classes. "For a month in February the Piarists made the 'externos' – as they

[14] A mondonguero is a tradesperson who prepares and sells intestines and other parts of cattle and swine.

called us students who could not afford tuition – carry up all the bricks needed to build the second story of the building on main street. Those who paid did not do it, of course," he told me in the summer of 2003, when I met him at his modest home in Toronto's Greektown.

Shortly after he began working at the Muñoz jewelry shop as an apprentice, then at the El Siglo bookshop. One day, Víctor Sarriá, a travelling salesman of the Victoria postcards brand, arrived in town. He offered Belsué a job in Zaragoza, for a wage of 300 pesetas. Thus began his years in Zaragoza and his first professional foray in design. He taught drawing at the Escuelas Pías and studied at the Escuela de Artes y Oficios under professors Félix Burriel and Luis Berdejo, although he has always identified as "self-taught in everything. I was an instructor before finishing my Bachelor's, my only title is that of Master Artisan, though I consider it an anecdote," he confessed at the same meeting.

The quality of his work allowed him to join, as a designer, the famed Quintana Studios specializing in religious fine metalwork. This was the fulfilment of a much yearned for dream. Years before, he had promised to design a mantle for Saint Eurosia, patron saint of Jaca, if he secured this job. He did so in 1958, and the mantle has since been exhibited every 25th of june to coincide with the feast day of the patron saint of the city. In this sense, Paco continued in the footsteps of his brother Santiago, who had become a renowned bookbinder and restorer.

Between 1956 and 1957, he worked intensely on the remodeling of the alcove of the Virgin of Pilar in Zaragoza and the design of the crown placed on the flower offerings. The stained glass windows, tabernacles, and altar rails of the Church of the small town of Caldearenas, in the Aragonese Pyrenees, are also of his design. A religious imprint is present in these first works and confirms the extent to which he made use of those childhood experiences among priests and altarpieces, "I know religious iconography to perfection and could work from a very young age, adapting its interpretations to my own taste."

The closing of the Quintana Studios forced him to specialize in advertising and graphic design. He combined this type of work, done under various agencies, with the artistic training he received alongside Natalio Bayo, Juan Tudela, and José Luis López Velilla, at the painting studio of Alejandro Cañada. In this way, metalwork and glasswork were precursors to

advertisements for Pikolín, Konga, or La Pitusa, popular soft drinks of the time. The closing ushered in the formation of a pioneering generation of superb, self-taught commercial artists specialized in the art of graphic advertising in Zaragoza. Francisco Belsué is one of this generation's main figures, but fate led him to distant Canada.

His friend Juan Tudela received a letter asking for Spanish commercial artists then highly sought-after in all publicity firms to work on an animated film. They were privileged in a glum and despairing Spain that was just beginning to flex with zealous industrial development and the incipient arrival of tourism. Belsué, who was then working at a Zaragoza agency and dreaming of other worlds without dictators, decided to respond to the call of prosperity and to resettle in a remote country which had not been a conventional destination for Spanish emigrants.

He started working at Savage Sloan Ltd., where he would later be assigned to design the logo of a newly-founded professional baseball team: the Toronto Blue Jays. It was the year 1977 when this ambitious project fell on Paco's drafting table. He had to play on the image of the blue jay, a bird of blue, white, and gray plumage which is common to the northeastern region of North America. After discarding a few initial sketches, he hit upon the definitive one: a predictable but effective combination of the aforementioned bird, a baseball, and a maple leaf –convenient shorthand for patriotism. Like that, out of Paco's hands and imagination emerged a design that over time would become one of the most iconic and profitable logos in Canada.

The work was signed by the agency and so Paco's creative contribution remained anonymous. As for the logo, within the first week of its market launch it generated ten million dollars in earnings. Paco only cashed his weekly cheque, he received no royalties. He was the anonymous artist behind one of the most popular logos of the country. The book *This Side of Spain: A Profile of Spaniards in Toronto*, edited in the 1980s, gives an account of the activities of the Spanish diaspora in Canada. In one of the notes, the author asks that Belsué's contribution "to Ontario and Canada occupy a place in the history of the country."

One has to live in Toronto to understand the hold the Blue Jays have on the city's inhabitants and how present the team is in their daily lives, matching the Maple Leafs and the Raptors.

When baseball season begins in the spring, the image Paco Belsué created permeates the entire city and all everyday objects. The Blue Jays are the only non-U.S. American team to have won the World Series. They did this for two consecutive years, in 1993 and 1994, a milestone marked in the country's history books is bold lettering. Rogers Centre, the formidable stadium where the team plays, is – along with the CN Tower – one of the most emblematic elements of Toronto's skyline.

Since Paco designed that first logo, the Blue Jays have modified and adapted it to contemporary styles so as to keep up with trends in marketing. Nonetheless, fans have always defended the original design, buying shirts and stamps with its image. The enterprise consequently decided, a few seasons ago, to restore it definitely and set aside any further visual experiments.

The Aragonese designer created other visual works for renowned firms such as American Express and Benson & Hedges, but never stopped being a talented, discreet, and efficient graphic designer whose work made his agencies and clients millions of dollars. Somewhere along the way he stopped being Paco and became Frank, though he always signed his emails as "Paco from Jaca." I suspect life did not treat him too well. His career, despite everything, was neither successful nor dazzling. His talent was squandered on lacklustre agencies and projects. As a result of this, his creativity and production gradually languished.

I met him in 2003, during the final stage of his life, when he, then retired, lived in a two-floor duplex in the crowded Greektown neighbourhood of South Toronto. The entrance to his house was presided over by a large painting of his featuring the Peña Oroel, the mountain of Jaca, and of other sketches of picturesque corners of Spain that remained etched in his childhood memory. There are ways of living modestly that sadden and others that dignify; the one permeating his home was of the latter kind.

On that occasion, we spoke at length about our town, which he had left half a century before and over which I vociferated like a herald bearing good news. His were vibrant and fertile memories of a life that was approaching its end, having shed all artifice. I wrote an article about our encounter for a Spanish magazine and we never saw each other again. He would once in a while send me increasingly infrequent emails with ideas, designs, and links to webpages documenting some global conspiracy or other. I believe what kept him going in his final years was the

conviction to remain alert in the face of all manner of plots being hatched around us to dominate the world.

A few weeks after I moved to Toronto, in October 2011, one of his nephews wrote to tell me that Paco had just passed away. I would like to think that fate brought this about in no haphazard manner, but with certain determinism: Paco left just as another Jacetano arrived in Toronto to take up the baton.

Joaquín Sorolla en su taller madrileño con su obra *Abuela y Nieta. Valle de Ansó*, c. 1911. Cortesía del autor.

Joaquín Sorolla in his Madrid studio with his work *Grandmother and Granddaughter, Valley of Ansó*, c. 1911. Courtesy of the author.

Marcelo Donato
Argentina

Marcelo Donato is an Argentinian-Canadian writer, architect, scenographer, cinematographer, and radio producer. His career includes studies and projects in Argentina, Mexico, Tokyo, Paris, and Canada, where he currently produces Perspectango, a tango radio show for CHIN Radio, Ottawa. He was the former theatre department supervisor at UNAM Canada between 2016 and 2019. His books *Entre bambalinas*, and *Picasso's Curtain* have obtained respectively the First Prize in the First Book Category (2017), and Honourable Mention (2021) at the International Latino Book Awards.

Translation by Luciana Erregue-Sacchi

El Telón de Picasso[15]

El viernes 20 de febrero de 1981 el Teatro Metropolitan de New York repuso el ballet *Parade* de Erik Satie. Luego del estreno se realizaron seis réplicas. La obra se repuso el 6 de diciembre de 1982 en otra breve temporada. En vez de usar la escenografía original de Pablo Picasso, el director de producción del Metropolitan de 1974 hasta 1981, John Dexter, junto a Gregory Evans decidió hacer una nueva co-producción, con un director de orquesta francés, Manuel Rosenthal que por primera vez dirigía la orquesta del Metropolitan a los 76 años de edad y un escenógrafo inglés, David Hockney en un triple programa que reunía el ballet a dos pequeñas óperas: *Las tetas de Tiresias,* de Francis Poulenc y *El niño y los sortilegios,* de Maurice Ravel. Y cuando digo pequeñas estoy hablando solamente de duración, ya que cada una dura algo menos de una hora. Sin embargo, se habla de obra maestra al referirse a *El niño y los sortilegios* y *Las tetas de Tiresias*, si no es maestra, es una de las únicas del siglo XX en su concepto de ópera bufa.

Tuve la fortuna de verlo y aún hoy, 35 años después, recuerdo esta puesta. Más por los colores fosforescentes de *El niño y los sortilegios* y la desfachatez del texto de Guillaume Apollinaire que inspira *Las tetas de Tiresias* que por algún rasgo de *Parade*. Nunca volví a ver algo tan impactante en la ópera, fue la primera y única vez en la que un torrente de color irrumpió ante mis ojos en un desfile de objetos y personajes que aparecían de los lugares mas disímiles del teatro en un delirio que parecía no tener fin. Era la tercer escenografía para ópera de Hockney, luego de *El progreso del libertino* (Glyndebourne festival, 1975) y *La flauta mágica*.

Hoy las circunstancias hacen que vea las cosas de un modo diferente. Desde el día en el que me enteré de que el famoso telón que Picasso había pintado para el ballet *Parade* no solo había visitado nuestro país, Argentina, sino que un rico coleccionista lo había adquirido en los años 30 o 40. En 1953 el telón viajó a Roma en calidad de préstamo para ser exhibido en un homenaje a Picasso. Allí fue re-descubierto por especialistas, quienes movilizaron curadores de los grandes museos europeos para intentar que el telón permaneciera en Europa. Francia hizo una oferta interesante y el telón nunca retornó a nuestro país.

[15] Nota del editor: La primera edición de *El telón de Picasso* fue publicada en español por la editorial Argus-a Artes y Humanidades, 2020.

La historia me pareció merecedora de un relato y es así como nace este libro.

Debo agradecer y dar crédito a dos periodistas: María Moreno, seudónimo de Cristina Forero, autora de la nota titulada "El rey Arturo" que Página 12 publicó el domingo 20 de octubre de 2002 y a Hugo Beccacece, autor de "Arturito: el príncipe ignorado," artículo que fue publicado el 29 de enero del 2006 en el periódico *La Nación*.

El telón de Picasso se exhibió en el Centro Pompidou en la primavera de 1991, luego en Barcelona, del 19 de noviembre del año 1996 al 23 de febrero del año siguiente, en la muestra *Picasso y el teatro*. Se volvió a mostrar después en el Palazzo Grassi de Venecia en 1998, como la pieza más importante de la muestra *Picasso (1917-1924)*. En el año 2001 el telón volvió a América Latina, esta vez a San Pablo, Brasil (OCA del parque Ibirapuera), en una muestra sobre el arte del siglo XX organizada por el Centro Pompidou. Luego llegó a Hong Kong, en el año 2004 donde cincuenta mil personas por día lo visitaron desde el 14 al 31 de octubre. En esta oportunidad el presidente de Francia, Jacques Chirac, develó el telón el día 12 de octubre. Y se desplegó nuevamente en el año 2012 en la muestra *1917* del Centro Pompidou de Metz, donde tuve la oportunidad de verlo. Esta exhibición ofrecía una vista panorámica de Europa antes de comenzar la Primera Guerra Mundial. Como dato insólito recuerdo que, entre todos los objetos exhibidos había uno solo en lengua española. Me acerqué curioso para ver de qué se trataba. Era un mapa de una parte de Argentina que mostraba el ferrocarril inglés que unía Buenos Aires con diversas poblaciones del interior entre las cuales figuraba Coronel Brandsen. Me quedé perplejo. En esta ciudad mis padres pasaron la mayor parte de sus vidas. Un tren emblemático para mí, que siempre me he desplazado en transportes públicos, un eslabón que une dos centros donde he transcurrido veinte años de mi vida, divididos en partes iguales; los diez de mi infancia en Brandsen y otros diez años antes de cumplir los cincuenta, en Buenos Aires. La existencia intermitente de este tren hasta el día de la fecha decide la organización de mis viajes cada vez que visito mi país.

Esta obra habla del teatro y de la danza. Comienza con una bailarina, Margaretha y se cierra con un dandi, Arturo. Entre estos dos puntos, al centro de esta obra hay una coreografía que cambió el curso de la danza: *Parade*. Un punto de inflexión en la historia de esta disciplina. No fue muy exitosa, aunque

si afirmamos esto entramos en el pantanoso terreno de los criterios del éxito que dividen a tantos teóricos. Prosigamos entonces, un ballet y un par de seres humanos. Los unía un rasgo muy particular, algunos dirán falta de memoria, otros quizás preferirán calificarlos como seres con un alto grado de creatividad y un último grupo los tildará de mentirosos. Él era de Acuario, ella de Leo. Él mentía porque quería sentirse parte de algo, ella porque no soportaba oír dos veces el mismo relato.

Alrededor de ambos se creó la leyenda de sus vidas donde la realidad y la fantasía se enredaron en un confuso vórtice de hechos. Ella lo pagó con su vida, él con su razón.

Como dice Javier Marías en su obra *Mañana en la batalla piensa en mí*:

> Vivir en el engaño o ser engañado es fácil, y más aún, es nuestra condición natural: nadie está libre de ello y nadie es tonto por ello, no deberíamos oponernos mucho ni deberíamos amargarnos. Lo que nos cuesta, lo malo, es que el tiempo en el que creímos lo que no era queda convertido en algo extraño, flotante o ficticio, en una especie de encantamiento o sueño que debe ser suprimido de nuestro recuerdo; de repente es como si ese período no lo hubiéramos vivido del todo, ¿verdad?, como si tuviéramos que volver a contarnos la historia o a releer un libro, y entonces pensamos que nos habríamos comportado de distinta manera o habríamos empleado de otro modo ese tiempo que pasa a pertenecer al limbo. Eso puede desesperarnos. Y además ese tiempo a veces no se queda en el limbo, sino en el infierno.

Mi tarea es la de tratar de salir del infierno y trazar una historia de uno de los elementos que conformaba la escenografía del ballet *Parade*, el telón de boca que Picasso pintó en 1917. Pero no voy a develarles nada más. ¡Que se alce el telón!

Margaretha Geertruida Zelle MacLeod
París, verano de 1905

Las luces se apagaron en el salón de la Baronesa Kireevsky. Sesenta aristócratas sentados en un teatro improvisado ansiaban ver el espectáculo. Un gong rompió el silencio y se iluminó la primera antorcha. Se abrió el cortinado negro y los

presentes pudieron divisar el cuerpo de una mujer recostado en el piso de una gruta sagrada. Se encendió la segunda antorcha y después una tercera. Cada antorcha que se iluminaba se acercaba al escenario donde Margaretha yacía en una pose sacada de una pintura de Paul Baudry. Se la veía apenas o, mejor dicho, se la adivinaba debajo de velos dorados y relucientes joyas.

Su respiración serena creaba un ligero movimiento en las telas y las piedras. Esta pulsación generaba destellos mortecinos a lo largo del cuerpo de la bailarina: un rito misterioso, una ceremonia secreta del Sudeste Asiático se representaba ante los ojos ávidos de un puñado de cultivados voyeurs.

Cuando sonaron las primeras notas de la cítara ella comenzó sus pausados desplazamientos: elevó sus brazos contorsionándose como un reptil. Sus movimientos eran sinuosos y lentos. No fue posible percibir en qué momento pasó de su postura acostada a la posición erecta, ya que sus miembros entrelazados y las contorsiones del torso producían un efecto hipnotizador que adormecía la razón y despertaba los instintos. De pronto su marcha se aceleró y, a las contorsiones se sumaron espasmos que sacudían sus miembros en movimientos calculados, siguiendo una mecánica de seducción y extrañeza.

Los velos que cubrían con delicadeza partes de su cuerpo se agitaron y empezaron a desprenderse como las hojas de un árbol ante la brisa. Los espectadores ignoraban la cantidad de capas de velos y el ritmo de la espera se hacía cada vez más acuciante. Una tras otra cayeron hasta dejar a Margaretha casi desnuda, con un bikini ornada de tiras de piedras preciosas que caían en forma de óvalos concéntricos. Era la primera vez que se veía en un salón parisino una danza de las Indias Orientales. Nunca se había contemplado tanto exotismo y desnudez enlazados en una danza de matices religiosos. Los espectadores quedaron hipnotizados, incapaces de discernir si lo que habían visto era una ilusión óptica, un sueño o una realidad.
Era una de las últimas noches del tórrido verano de 1905.
Entre el público había ministros, militares, diputados y senadores, industriales, banqueros y artistas. Cuando la bailarina reapareció entre los espectadores a disfrutar los platos exquisitos y el champagne que la baronesa ofrecía con generosidad, acaparó la atención tanto de los hombres que halagaban sus dotes naturales, como de las mujeres que

lisonjeaban sus habilidades artísticas. Era la primera noche que ella se sentía feliz en sus treinta años de ajetreada vida.

La habitación 327 del Grand Hotel de París donde vivía se llenó de flores y tarjetas. Pasadas las primeras horas no hubo más lugar en la alcoba donde ubicar tantos obsequios. Las flores seguían llegando y se alineaban en el corredor del piso del hotel, mientras las tarjetas flanqueaban la puerta. Entre estas, la bailarina extrajo las más prometedoras, de artistas e intelectuales que la invitaban a bailar en sus salones. Entre las ofertas se destacaba la de Émile Guimet, quien, muy interesado en las artes orientales, la convocaba a exhibirse en el museo que aún hoy lleva su nombre. Su sueño se hacía realidad.

El 18 de octubre llegó a París la cita anual más esperada de las artes plásticas: el Salón de otoño. En esta tercera edición se presentaron 1625 obras en el Grand Palais. El presidente de la República, Émile Loubet, había rechazado la oferta de inaugurar el salón: le habían llegado comentarios de la participación de obras "inaceptables." La sala VII de la muestra fue la más osada: allí se pavoneaban espantadas las damas de la sociedad frente a *La mujer con sombrero,* de Matisse y el *León hambriento atacando a un antílope,* de Rousseau. Los fauvistas habían acaparado la atención de los críticos, que se dividían en dos grupos irreconciliables. El que contaba con más simpatizantes se preguntaba donde había ido a parar el savoir-faire y consideraban la muestra ofensiva. Sus oponentes en cambio abrazaban los cambios y daban la bienvenida a este grupo de artistas que traía una brisa fresca, lúdica y amoral en su desenfado cromático y formal.

Y llegó el invierno y Margaretha bailó en el Museo Guimet. El 13 de marzo de 1906 realizó la anhelada presentación ante cien espectadores, entre los cuales había periodistas de los medios más importantes nacionales y extranjeros. Aquí la escenografía era más elaborada. Una imagen de la divinidad Shiva en un templo colmado de flores era el altar donde Margaretha iba a entregar su sacrificio... y sus velos. Cuatro acólitos acompañaban sus movimientos enfundados en austeras togas negras, mientras ella ostentaba las sedas, las vestiduras doradas y exóticas piedras de colores. Sobre su negra cabellera un áureo tocado otorgaba un aire más exótico aún a la bailarina. Los críticos la aclamaron, nadie dudaba de su profundo conocimiento de las danzas rituales orientales.

Ella empezó a usufructuar esa fama, seduciendo a los admiradores más ricos para obtener grandes beneficios. La pluralidad no le asustaba, así que sus ganancias aumentaron en progresiones geométricas. Del Grand Hotel se mudó a un departamento del edificio número 3 de la Rue Balzac. Antes de mudarse decoró y redecoró cada centímetro de la morada en idas y venidas que acabaron con la paciencia de los obreros y torturaron la inventiva de los decoradores. Había contratado además cuatro personas a su servicio: una cocinera, un chofer, una especie de secretaria personal y un cochero para su carruaje. Sus gastos excedían sus ingresos, pero para ella ese era un detalle sin importancia. Ofrecía fiestas con costosos vinos y platillos. Compraba conjuntos de collares, brazaletes y tocados de rubíes para futuras presentaciones porque nunca repetía sus vestuarios. Hay que reconocer que sus oportunidades crecieron al ritmo de sus gastos: en agosto el teatro Olympia estuvo a sus pies, gracias a Gabriel Astruc, su flamante representante, que negoció sus espectáculos de danza con gran habilidad, solicitando cachets cada vez más abundantes. Siguieron presentaciones en Madrid, Berlín y Viena. En Montecarlo bailó en el estreno de la ópera *El rey de Lahore*, de Jules Massenet, el primer éxito del compositor, que quedó encantado y obsesionado con la musa danzante.

Serge Diaghilev

Diaghilev vestía muy elegante y no escondía su homosexualidad. Era alto, algo excedido de peso, los ojos un poco caídos, la nariz recta y un espeso bigote negro enmarcaba sus labios carnosos. Su compañía de danza había trascendido las fronteras de Rusia. Durante la guerra decidió dejar su patria y eligió Roma como base de operaciones. Llevaba una vida ostentosa y ofrecía cenas en donde se podían oír conversaciones en inglés, francés, español, ruso e italiano. Gran conocedor de arte, lleno de charme y distinción, perdía los estribos en los ensayos y en su alcoba se volvía un dictador. Casi todos pasaban este detalle por alto: bailar en su ballet y entrar en su círculo de amistades era un privilegio de pocos.

Afortunado en su labor profesional, no se podía decir lo mismo de su vida sentimental: sus dos ex amantes lo habían abandonado por una mujer. Ahora era el turno de Léonide. Ambos sacaban partido de la situación; para él, acostarse con Serge era el precio a pagar por ser un bailarín étoile.

Cuando se conocieron Picasso y Léonide, descubrieron ipso facto una afinidad: el gusto por las mujeres. Y al tiempo, otra más: los temas hispanos. Muy pronto se los vería trabajar en un proyecto conjunto, *El sombrero de tres picos*.

El viaje a Roma fue una fiesta constante. El primer día fueron al Coliseo. Luego visitaron los Museos Vaticanos, cayendo bajo el influjo de Rafael y de Miguel Ángel. A insistencia de Jean, pidieron una audiencia a Benedicto XV. El papa se la negó, aduciendo que ya había bendecido al Ballet Ruso. Para distraerlos de este agravio, Serge les propuso un viaje a Nápoles del 9 al 13 de marzo.

Esa misma semana, en Rusia, durante los festejos del Día de la mujer, se habían producido una serie de revueltas que desembocarían en la Revolución de 1917.

Picasso se enamoró de Nápoles a primera vista. Quizás por recordarle a la Málaga de su infancia. O tal vez por la belleza del golfo, la presencia del Vesubio y la vitalidad de la vida callejera. Esta ciudad lo impactó más que Roma. El 5 de abril llegó otro amigo de Serge, Igor Stravinsky, que inmediatamente hizo migas con Pablo. Era el artista que Cocteau había tratado de persuadir para crear la música de su ballet *David*. Picasso y Stravinsky eran vanguardistas. Se enfrentaban al pasado con sus obras y las dificultades que encontraron en su camino los hizo hermanarse en su lucha.

Diaghilev frecuentaba la alta sociedad romana y organizó veladas para introducir a sus amigos Cocteau y Picasso. Aquí salieron a relucir aspectos ocultos de sus personalidades: mientras Jean amaba las fiestas, las largas charlas y el dolce far niente, Pablo prefería la acción, o sea, la pintura. De hecho, realizó dos obras antes de meterse de lleno en la escenografía de *Parade*. Había venido a Roma a crear los decorados y vestuarios para un nuevo ballet y prefería evadir los compromisos sociales. Diaghilev quería presentarle a la Marquesa Casati y Pablo encontró una excusa inexorable.

—No traigo smoking…

Esta frase se convirtió en su slogan. Pablo quería divertirse a su manera y puso la mira en una de las bailarinas del ballet, Olga. Ella tenía 25 años y unos hermosos ojos verdes que contrastaban con su cabello pelirrojo oscuro. Y era muy

talentosa: para entrar al ballet había que pasar una rigurosa audición donde Serge junto a su anterior amante y un tal Cecchetti configuraban un terrorífico trío. Pablo, deseando olvidarse de Irene, comenzó a flirtear con Olga. Le hizo un dibujo y pensó que eso bastaba. ¡Pero ella era virgen y rusa! Al menos en esa época una rusa tenía que llegar virgen al matrimonio. Pablo no lo podía creer. Nunca había tenido que esforzarse tanto para conseguir una mujer. Se había enamorado de ella a primera vista, viéndola bailar durante el ensayo de *Las mujeres de buen humor* en el rol de Dorotea.

Picasso se ofreció para trabajar junto a Carlo, el realizador de la escenografía del espectáculo y ayudó a los tramoyistas la noche del estreno, el 12 de abril. Tenía dos objetivos en mente: el primero, familiarizarse con las artes escénicas, que enfrentaba por vez primera y el segundo, cruzarse con Olga en los pasillos del teatro y, cuando la ocasión se presentara, tratar de seducirla.

Pablo golpeaba a la puerta de su habitación del hotel Minerva.

—No, no, señor Picasso, no lo voy a dejar entrar.

Serge Diaghilev no los apoyaba. No quería enfrentarse a los padres de Olga, que pretendían un mejor partido para su hija. Además, en su compañía quería bailarines sin ataduras. Le propuso a Picasso esperar unos días para presentarle una bailarina que estaba en gira.

Pablo dibujó el telón de *Parade* en el taller ubicado en Via Margutta número 53b en un estudio perteneciente a los Patrizzi, una familia de la nobleza italiana. Los artistas que Picasso iba conociendo lo ayudaron a concretar su titánica labor. Fortunato Depero fue uno de ellos. Él lo introdujo al mundo de los futuristas, presentándole a su amigo Enrico Prampolini.

Pablo se quedó extasiado ante la grandeza de sus obras y la pequeñez de su habitación. Decidieron salir a festejar el encuentro al Café Greco, donde los esperaban Léonide y Jean. Este último compró una postal para enviarle a Erik, que se había quedado en París.

Jean, a pesar de su preferencias, decidió también embarcarse en una relación con una joven bailarina, María. Ella no era ninguna tonta, ya que Jean usaba más maquillaje que ella, sin embargo, se divirtió durante el tiempo que duró la estadía...

El 16 de abril Serge le propuso a Pablo y a Léonide volver a Nápoles antes de regresar a París. Esta vez viajaron en tren, acompañados por Igor y otro amigo. En el trayecto hicieron una apuesta: Pablo tenía que hacer un retrato de Léonide en menos de cinco minutos con el tren en movimiento. Pablo ganó la apuesta y le regaló el retrato al modelo. En este viaje gozaron cada rincón de la ciudad. Caminando por la Forcella, tuvieron la oportunidad de ver funciones callejeras de la commedia dell'arte con los personajes que van a aparecer en obras posteriores de Pablo Picasso: Arlequín, Colombina, Pantaleón, Polichinela, el Capitán, Brighela, Scapino y Scaramouche.

Las actuaciones de estos personajes tienen mucha acción, contacto con la tierra y los sentimientos terrenales, grandilocuentes gestos, alguno de ellos obscenos y gritos, muchos gritos. Todos usan máscaras, lo que le da a la representación un tinte particular. A Léonide se le ocurrió hacer un ballet basado en la commedia dell'arte. Todos estuvieron de acuerdo y decidieron iniciar una investigación seria, para lo cual se dirigieron al Museo de San Martino, el lugar más idóneo en toda la ciudad para concretar este plan. Se centraron en el personaje de Polichinela, las marionetas y la tradición napolitana. Pablo estaba fascinado también por las esculturas griegas y romanas del museo. La visión del Hércules lo dejó sin respiro por su tamaño y además por el trabajo del artista para reforzar, con algunos ajustes en las proporciones, el sentido de magnitud.

A finales de abril regresaron a Roma y siguieron viendo espectáculos. Pablo terminó sus bocetos de vestuario y escenografía de estilo vanguardista y se los mostró a Jean. Juntos decidieron crear más personajes, dos hombres de negocios que se unían a los artistas del desfile. Luego de una breve estadía en Florencia, a inicios de mayo volvieron a París. Serge en cambio tuvo que dirigirse primero a Montecarlo y después continuó su viaje hacia la Ciudad Luz.

El misterio Arturo

Al igual que Mata Hari, el telón pasó a ser una sigla, AM 3365P, pieza adquirida en 1955. Hoy forma parte de la colección del Museo de Arte Moderno, que ahora funciona en el Centro Georges Pompidou. En la ficha de la obra no hay información sobre la estadía en Sudamérica, no figura Buenos Aires ni

Arturo, solo un lugar en blanco. En el año de la adquisición Picasso seguía activo, filmando un documental con el cineasta Henri-Georges Clouzot. La obra, *El misterio Picasso*, ganó el Premio Especial del Jurado del Festival de Cannes en 1956. Ese mismo año Arturo escribía críticas de espectáculos para la revista Mundo Argentino. Trabajó en Radio Municipal y luego en el Museo de Arte Moderno, cuando funcionaba en el edificio del Teatro San Martín, en Corrientes al 1500. Él trabajaba de una manera sui generis. Según sus compañeros de oficina, no tenía noción de lo que era el dinero. Eso sí, a la hora de hacer teatro, se posesionaba y hablaba de reyes de Inglaterra y Francia como si fueran sus iguales. Poco a poco, sin que se diera cuenta, su desorden administrativo y su generosidad causaron estragos.

¿Qué perdió primero Arturo: la razón o la fortuna heredada de su madre? O acaso ambas estaban enlazadas. Nadie lo sabe, nadie se acuerda. Todos se divertían oyendo sus historias, medio verdades, medio inventadas. Él estaba solo y con esa especie de abandono que había sabido cultivar. Le preocupaba el paso del tiempo, pero era una inquietud más vinculada a las cosas y los lugares que a los seres humanos, a quienes bautizaba con nombres de personajes de obras clásicas.

Como su querida Mata Hari, de los lujosos hoteles pasó a los más modestos, del Crillón al Lepanto donde compartió habitación junto al irreverente autor y artista plástico Alberto Greco en los años 60. Arturo tenía un modesto puesto en Radio Municipal. Greco se fue a España donde se suicidó en 1965 y Arturo se mudó a un departamento en la Avenida Córdoba entre San Martín y Reconquista.

Aquí solo le quedaba una estatuilla de Rodin, una cómoda de laca china, dos jarrones Ming, una edición deslumbrante de la obras completas de Shakespeare, el retrato de Hector Basaldúa, las obras completas de Dickens y un puñado de amigos. Era un departamento en planta baja al fondo. No perdía ocasión para dejar regalos, generosidad que ostentó hasta el fin de sus días. No podía regalar esmeraldas, pero sí pequeños objetos de lujo, casi siempre fuera del alcance de quienes lo recibían.

Habla el telón...

El telón quiso tomar la palabra y yo no se la podía negar, así que a continuación transcribo lo que me dijo:

"Cien años parecen mucho pero el tiempo pasa velozmente y ¡zas!, de repente ya los tienes... Recuerdo mi nacimiento, viajando entre Roma y París. Siento aún los pasos de mis creadores y el calor de los futuristas que ayudaron a mi padre a concretar el proyecto.

Cada trazo, cada pincelada me fueron dando un carácter. Una escena circense es lo primero que llama la atención, aunque luego vemos que algunos de los integrantes pertenecen a un mundo fantástico, el de los seres alados. Por eso hay algo tan particular en mí... Al fondo se ve el Vesubio en toda su fuerza y el mar.

Todo fue vertiginoso hasta la noche del estreno. De ahí en más mi vida fue tranquila y sin cambios considerables hasta mis veintidós años. Pensé que la exhibición en Buenos Aires iba a ser una más, pero no fue así.

Primero por el viaje, ¡nunca había hecho uno tan largo! Y después los acontecimientos de dominio público, la guerra, que hicieron que me tuviera que quedar allí por diez años.

Esta década fue fundamental en mi vida, conocí el aire libre, las pampas argentinas y entablé amistad con un ser muy especial, Arturito, mi mejor amigo. ¡Que ser tan particular! ¡Qué sensibilidad! ¡Qué hombre tan cultivado! Si hay alguien en este mundo que me ha valorado en todo mi ser, ese fue Arturo.

En América mi vida cambió. De la oscuridad del teatro pasé a la luz enceguecedora del sol. De la multitud de la ciudad pasé a la completa soledad del campo. De los cuchicheos del público pasé a escuchar los diálogos de los eucaliptus en la gran avenida de la estancia de Arturito, La Melchora.

Pero la felicidad es pasajera y una exposición me devolvió a Roma, mi tierra natal y a la vida cotidiana. Miles de personajes desfilaron ante mí, como en las otras muestras, pero al finalizar la exhibición un grupo de entendidos quiso cambiar mi camino. Yo trataba de desentenderme del asunto, pero llegó un momento en que me preocupé por mi suerte. Estaba en La

Scala. ¡Qué hermoso teatro! Me levantaron una mañana, entre un montaje de una ópera poco conocida y otro de *Norma*. Desfilaban importantes curadores enviados de museos de diferentes países europeos hasta que alguien, con acento francés, decidió mi futuro. Nadie me consultó. No les interesaba mi opinión, si yo quería permanecer a la sombra de los eucaliptus o envuelto en un depósito entre cada exposición. Y fui a Francia, a París, para ser más exactos. Y volví a las andadas, de exposición en exposición, pero mi corazón quedó en la pampa argentina.

Hoy Arturo ya no está y yo continúo mis viajes. El último a Roma, a festejar mis cien años. ¡Y creo que me queda vida para rato!"

Picasso's Curtain: A Visual Encounter[16]

On February 20, 1981 the Metropolitan theatre in New York reprised *Parade*, a ballet by Erik Satie. After the premiere, there were six more functions. The production resumed on December 6, 1982 for another brief run. John Dexter, the Metropolitan's production director between the years 1974 and 1981 decided, together with Gregory Evans, that French conductor Manuel Rosenthal would lead the orchestra. At 76 years old, this was Rosenthal's directorial debut with the Metropolitan Orchestra. Instead of employing the original sets by Pablo Picasso, Dexter and Evans chose a British set designer, David Hockney. The triple program included the ballet, and two small operas, *The Breasts of Tiresias,* by Francis Poulenc, and *The Child and the Spells,* by Maurice Ravel. When I say small operas I refer only to their short duration, since each of them lasts less than an hour. Ravel's piece is considered a masterpiece, Poulenc's is, if not a masterpiece, one of the few outstanding opera buffa of the twentieth century.

I had the good fortune of seeing this performance. Even today, 35 years later, the fluorescent colours of *The Child and the Spells* and the text by Guillaume Apollinaire which inspired *The Breasts of Tiresias* bring me back to the production much more than any detail from *Parade*. I had never seen something as impactful in the world of opera. It was the first and only time a torrent of color flooded my eyes in a caravan of objects and characters appearing out of the most unlikely corners of the theatre in a never-ending delirium. It was Hockney's third set design for an opera after *The Progress of the Libertine* (Glyndebourne Festival, 1975) and *The Magic Flute.*

Circumstances today make me see this experience in a different light. Everything changed after I found out that the famous curtain Picasso had painted for the ballet *Parade* not only had visited my country of birth, Argentina, but that a wealthy collector had acquired it between the 1930s and 40s. In 1953 the curtain travelled to Rome on loan as part of a Picasso retrospective. There it was re-discovered by specialists, who called on the curators of the most renowned European museums to make sure Picasso's curtain remained in Europe.

[16] Note from the Editor: The first edition of *Picasso's Curtain* was published in Spanish under the title *El telón de Picasso* by Argus-a Artes y Humanidades/Arts & Humanities, 2020.

France made an interesting offer and the curtain never returned to Argentina. This event deserves to be told, and this is how the book whose excerpt you are reading, was born.

I am grateful and must give credit to two journalists, Cristina Forero, under the pen name María Moreno, and Hugo Beccacece. Cristina authored an article titled "King Arthur" published on October 20, 2002 in Argentinian daily *Página 12*. Beccacece is the author of "Little Arthur: The Snubbed Prince" an article published on January 29, 2006 in Argentina's daily, *La Nación*.

Picasso's curtain was exhibited at the Centre Pompidou in the Spring of 1991, then in Barcelona at the show *Picasso and the Theatre* from November 19, 1996 to February 23 of the following year. It was later shown in 1998 at the Palazzo Grassi in Venice as the centerpiece of the exhibition *Picasso (1912-1924)*. In 2001 the curtain returned to Latin America, this time to Sao Paulo, Brazil (OCA, at Ibirapuera Park) as part of a show on twentieth-century art organized by the Centre Pompidou. Between October 14 and 31, 2004, fifty thousand people visited the curtain when it travelled to Hong Kong. For this occasion, France's President Jacques Chirac unveiled the curtain on October 12. Picasso's curtain was last exhibited in 2012 at the show *1917* at the Centre Pompidou in Metz, where I had the chance to see it. This exhibition offered a panoramic view of Europe before the start of World War I. As a curious aside, I remember that amongst the documents on display only one was in Spanish. I got closer to see what it was about. It was a map of a section of Argentina's English-built railway connecting Buenos Aires with the interior. Amongst these locales figured the town of Coronel Brandsen where my parents had lived for most of their lives. I was perplexed. This train is meaningful to me, I have always embraced public transportation; the train is the link joining twenty years of my life, my first ten years of life in Brandsen, and my fortieth decade, living in Buenos Aires. To this day, the train's intermittent existence determines how I organize my itinerary each time I return to Argentina for a visit.

This piece is about theatre and dance. It begins with a dancer, Margaretha, and closes with a dandy, Arturo. Between these two points, at the centre of this play lies a choreography which changed the course of dance: *Parade*, a turning point in the history of the discipline. The ballet was not terribly successful, although if we agree with this assessment we enter in the muddy waters of the measure for success that divides so many theorists. Let's continue, then, a ballet and a couple of humans.

An extremely particular trait connects them. Some will argue for memory lapses, others may prefer to see them as people with a high degree of creativity, a last group will consider them nothing more than a pack of liars. He was under the sign of Aquarius, she was a Leo. He lied because he wanted to feel part of something. She lied because she could not stand to hear the same tale told twice.

And then the legend of their lives emerged, where reality and fantasy enmeshed in a confusing vortex of facts. She paid with her life. He paid with his sanity.

As Javier Marías writes in his play *Tomorrow in the Battle Think on Me*;

> To live in deception or to be deceived is easy, besides, it is our natural state: no one is free of this, nobody is stupid because of it, we should not feel bitter or fight it too much. What is really onerous, the negative, is when we believe in what never existed. It transforms into something strange, suspended or fictitious, in a kind of spell or dream which must be excised from our memory; as if suddenly we had never fully lived, right? As if we had to retrace the beginning of the story, the re-reading of a book, and then we think of how we would have behaved differently, or how we would have spent that time in any other way, which now belongs in limbo. This can cause despair. Furthermore, that time does not always remain in limbo, but in Hell.

My task is to get us out of Hell by delineating the story of one of the elements belonging to the set of the ballet *Parade*, the stage curtain that Picasso painted in 1917. I will not reveal anything else. Curtain call!

Margaretha Geertruida Zelle MacLeod
Paris, Summer 1905

It was lights-out at the reception room of Baroness Kireevsky. Sixty aristocrats, seated in a makeshift theatre anxiously awaited for the spectacle to commence. A gong broke the silence and the first torch lit up. The black curtain opened, and the audience glimpsed the body of a woman lying on the

ground of a sacred grotto. Then a second torch, and a third. With each of them the viewers got a closer look at the stage where Margaretha lied as if in a painting by Paul Baudry. She was barely visible, her presence divined only by the shimmering jewelry and golden veils draped all over her body.

Her serene breathing created a subtle movement of the fabrics and the gems. This pulsation produced imperceptible flickers alongside her body: a mysterious rite, a secret ceremony from South East Asia played out before the avid gaze of a handful of discerning voyeurs.

At the first notes of the sitar the ballerina imperceptibly began to glide: she raised her arms, slithering like a reptile, her movements oscillating and slow. It was impossible to notice when she transitioned from supine to erect. Her interlaced extremities and the twisting motion of her torso produced feelings of suspended reasoning, awakening the instincts of her mesmerized audience. Suddenly her rhythm accelerated, adding spasms to the contortions, causing her extremities to vibrate in calculated movements, following a strange mechanic of seduction and intrigue.

The veils delicately covering parts of her body began to pulsate and abandon her body like the leaves of a tree under a breeze. The audience had no inkling as to how many layers of veils remained, the wait had a tangibly urgent aura. As they fell one after another, all that was left on Margaretha's partially barenaked body was only a bikini, adorned with ribbons of precious stones dripping in concentric ovals. It was the first time a Parisian salon had witnessed a dance from the Indian subcontinent. The city had never seen so much exotism and nudity woven throughout a dance with religious overtones. As if hypnotized, the audience could not discern whether they had witnessed an optical illusion, a dream, or a real life event.

The event took place on one of the late, torrid summer nights of 1905. Between the audience there were ministers, military men, members of the French Parliament, industrialists, bankers, and artists. When the ballerina re-emerged amongst the public, she made a line for the exquisite dishes and the champagne the baroness had generously provided. The presence of Margaretha garnered the interest of the men who complimented her natural attributes, and the attention of the women, who commended her for her artistic abilities. It was the first night in thirty years of hectic living she felt true joy.

Room 327 of the Grand Hotel de Paris where she lived was filled with flowers and cards. Past the first hours there was no room left to place the many gifts. The flowers continued arriving and lined up the adjacent corridor, while the cards accumulated by the door. From those, the ballerina selected the most promising ones, the invitations by artists and intellectuals who asked her to dance at their salons. One of them stood out, Èmile Guimet was most interested in the arts of the East, and requested her to perform at the museum that still today bears his name. Her dream was becoming a reality.

The Paris Salon d'Automne on October 18 was the most important date in the calendar of the Fine Arts world. Its third edition saw 1625 works of art on exhibition at the Grand Palais. The president of the Republic, Èmil Loubet had turned down the invitation to open the salon: he had heard through the grapevine some of the works were deemed "unacceptable." Room VII of the exhibition was the most daring: French society ladies paraded their shocked expressions in front of the *Woman With a Hat,* by Matisse and the *Hungry Lion Attacking an Antelope,* by Rousseau. Fauvists had captured the attention of the critics, divided between two rival groups. The most popular with the salon audience found the exhibition offensive, wondering where was the savoir-faire. The opposing group embraced the changes afoot, rolling out the red carpet to the artists bringing a breath of fresh, ludic, amoral air in their chromatic and formal abandon.

With the arrival of fall, Margaretha finally danced at the Guimet Museum. On March 13, 1906 she presented the much anticipated spectacle before an audience of a hundred, amongst them members of the most important national and international media outlets.

The stage design was more elaborate this time. An image of Shiva, inside a temple adorned with flowers was the shrine where Margaretha would sacrifice herself...and her veils. Four acolytes, in austere black togas, followed her every move as she flaunted her silks, her golden dress, her ornate garment dripping with coloured stones.

On her jet-black mane, a golden headdress conferred Margaretha an even more exotic aura. The critics acclaimed her performance, nobody doubted her profound knowledge of ritual dances from the East.

As her fame rose, she started to profit from her success, seducing her richest admirers to obtain substantive benefits. She was not scared of having to juggle multiple suitors, as her earnings grew in geometric progression. From the Grand Hotel she moved to an apartment in a building at Number 3, Rue de Balzac. Before the move she decorated and redecorated every centimetre of her new dwelling, testing the patience of tradesmen and decorators. She also hired four service people: a cook, a chauffeur, a personal assistant of sorts, and a coachman for her carriage. Her expenses exceeded her earnings, in her eyes, an insignificant detail. She threw parties offering expensive wines and delectable dishes, she would also buy parures with rubies for future presentations, because she never repeated her outfits. Her opportunities, though, grew at the same rhythm as her expenses. In August she had the audience at the Olympia theatre at her feet, thanks to Gabriel Astruc, her new manager, who negotiated her dance contracts with uncanny ability, requesting ever higher artist fees. Presentations in Madrid, Berlin, and Vienna followed. In Montecarlo she danced for the premier of the opera *The King of Lahore,* by Jules Massenet, his first great success as composer. Massenet became infatuated, and obsessed with the dancing muse.

Serge Diaghilev

Diaghilev dressed elegantly and never hid his homosexuallity. He was tall, somewhat overweight, eyes heavy-lidded, with a straight nose and a thick moustache framing his full lips. His ballet company had transcended the Russian borders. During WWI he decided to emigrate and chose Rome as his base of operations. His lifestyle was one of ostentation, offering dinners where one could hear conversations in English, French, Spanish, Russian and Italian. A great art connoisseur, full of charm and distinction, he lost it during rehearsals. In the bedroom, he was a dictator. Almost everyone ignored such quirky details: to dance with his ballet and enter his inner circle of friends was a privilege of the few.

Fortunate in his professional life, the same could not be said of his love life: Diaghilev's two former lovers had left him for women. Now it was Léonide's turn. They both took advantage of their situation; for Léonide, to go to bed with Serge was the price to pay for being the star dancer.

When Picasso and Léonide met, they discovered an immediate affinity: a taste for women. In time, they discovered one more: their taste for all things Spanish. Soon the public would see them work together on a common project, T*he Three-Cornered Hat*. The trip to Rome was one endless party. The first day they visited the Colosseum. Then the Vatican Museums, falling under the spell of Raphael and Michelangelo. To the insistence of Jean they requested an audience with Pope Benedict XV. The Pope denied their request arguing he had already blessed Diaghilev's Ballet Russes. To distract the group from such an affront, Serge proposed a trip to Naples from March 9 to 13. That same week, during the celebrations of International Women's Day in Russia, a series of scuffles would contribute to fuel the fires of the Revolution of 1917.

Picasso's love for Naples came at first sight. Perhaps it reminded him of the Malaga of his childhood. Or perhaps because of the beauty of the Gulf, the presence of Vesuvius, and the exuberant street life.

This city impacted him more than Rome. On April 5 another friend of Serge, Igor Stravisnky arrived in Naples and instantly became Friends with Pablo. He was the artista Cocteau had tried to persuade to créate the music to his ballet *David*. Picasso and Stravisnky were avant-garde artists. They confronted the past with their work and the difficulties they encountered in their paths made them brothers in arms.

Diaghilev frequented Rome's high society and organized parties to introduce his friends Cocteau and Picasso. It was at these events where hidden aspects of their personalities rose to the surface: while Jean loved to party, long conversations and the dolce far niente, Pablo was a man of action, painting. In fact, before diving into the set designs of *Parade*, he completed two paintings.
He had arrived in Rome to create the sets for a new ballet and preferred to eschew social commitments. Diaghilev wanted to introduce him to the Marchesa Casati and Pablo found the most outlandish excuse.

—I did not bring a tuxedo...

This retort became his slogan. Pablo wanted to enjoy life on his own terms and set sights on one of the ballerinas from the corps de ballet, Olga. She was 25 with stunning green eyes which contrasted with her dark red hair. She was especially talented: to

enter the ballet, aspiring candidates had to audition in front of a terrifying trio formed by Serge, his past lover, and one Cecchetti guy.

Pablo, hoping to forget Irene, began to flirt with Olga in earnest. He produced a drawing for her, and thought that was enough. It turns out she was a virgin, and a Russian! At least at that time, it was expected someone like Olga arrived a virgin to the altar. Pablo could not believe it, he had never had to go through such efforts to enamour a woman. His was love at first sight, seeing her dance during the rehearsal of *The Good-Humoured Ladies* in the role of Dorothea. Picasso offered to work alongside Carlo, the scenographer, and helped the stagehands on the night of the premiere, April 12. He had two goals in mind: the first, familiarizing himself with the scenic arts, a discipline he was encountering for the first time, second, he was hoping to cross paths with Olga behind the scenes, and when the occasion arose, to try and seduce her.

Pablo knocked on the door of her room at Hotel Minerva.

—No, no, Mr. Picasso, I will not let you in.

Serge Diaghilev did not support their courtship. He did not want to face Olga's parents, who aspired for someone from better social standing for their daughter. He also wanted his dancers as unattached as possible. He proposed Picasso to wait a few days to introduce him to a dancer on tour.

Pablo drew the curtain for *Parade* at the workshop located on Via Margutta number 53b in a studio belonging to a family from the Italian nobility, the Patrizzi.

The artists Picasso was meeting there, helped him to execute his titanic labour. Fortunato Depero was one of them, introducing him to the world of Futurism, and his friend, Enrico Prampolini.

Pablo was ecstatic before the grandeur of his works inside his tiny studio. They celebrated their encounter at Café Greco, where Léonide and Jean were waiting for them. Jean bought a postcard for Erik, who had remained in Paris. In spite of his preferences, Jean also decided to embark in a relationship with a young ballerina, Maria. She had noticed Jean wore more makeup than her, yet she went right along, enjoying herself during his stay.

On April 16, Serge proposed Pablo and Léonide to head to Naples again before returning to Paris. This time they travelled by train with Igor and another friend. During the journey they challenged Pablo to sketch a portrait of Léonide in less than five minutes with the train in motion. Pablo won the challenge, gifting the portrait to the model. They enjoyed every corner of the city. Walking by the Forcella, they came across street performances of Commedia dell'arte with the characters viewers would later see on Picasso's work: Harlequin, Pantalone, Pulcinella, Il Capitano, Brighella, Scarpino, and Scaramouche.

The performances of these characters are imbued by physicality, earthiness, earthly feelings, exaggerated gestures, some of them obscene, and shouting, lots of shouting. They all wear masks, which gives the performances a distinctive imprint. Léonide thought of creating a ballet based on the Commedia dell'arte. They all agreed, and began conducting serious research immediately, heading to the San Martino Museum, the most suitable place to complete the project. They focused on the character of Pulcinella, marionettes, and the Neapolitan tradition. Pablo was also fascinated by the museum's Greco-Roman sculptures. The sighting of Hercules left him breathless. It was not just its size, it was also the craftsmanship of the artista to reinforce, within proportions, the sense of magnitude. At the end of April they returned to Rome and continued going to shows. Pablo finished his avant-garde sketches for the costumes and set designs, and showed them to Jean. They decided to create more characters, two businessmen who would join the artists at the parade. After a brief stay in Florence, they returned to Paris at the beginning of May. Serge instead decided to head first to Montecarlo, to finally make it to the City of Lights.

The Mystery of Arturo

Just like Mata Hari, Picasso's curtain became a siglum, AM 3365P. It was acquired in 1955 by the Museum of Modern Art, now part of the Centre Georges Pompidou. In the corresponding file we only see a blank space instead of information on the curtain's South American sojourn. The city of Buenos Aires is nowhere to be seen. Neither is Arturo, son of Elvira Agostinelli, and Arturo Álvarez Insúa. She claimed to be a relative of Alfred Agostinelli, chofer of Marcel Proust. He, a military man, claimed to be an illegitimate child.

In 1955, Picasso was very much active, filming a documentary with director Henri-Georges Clouzot. The film, *The Mystery of Picasso*, obtained the Cannes Festival Special Jury Prize in 1956. That same year, Arturo was writing an entertainment column for the magazine *Mundo argentino*. He worked in Radio Municipal, and the Museo de Arte Moderno, today, the building of Teatro San Martín, on Corrientes Avenue 1500. His work habits were utterly sui generis. According to his office colleagues, he had no idea of the concept of money. However, he could embody royalty with theatrical gestures, like a man possessed, when speaking of the kings and queens of England and France as if they were his peers.

Little by little, unbeknownst to him, his disordered work habits, and his generosity tore through his life. What did Arturo lose first, his reason or his fortune, inherited through his mother? Were they intertwined? Nobody knows, nobody remembers. Everybody loved listening to his stories, half true, half invented. He was all alone, with this abandonment of the self he had learned to cultivate so well.

The passage of time anguished him, with a preoccupation about objects and places, more than about the people in his life. He had the habit of re-naming them after characters of classical plays.

Like his beloved Mata Hari, he went from dwelling in the fanciest hotels to the most modest. He went from the Crillón to the Lepanto, sharing a room with irreverent author and artist Alberto Greco during the 1960s. While Arturo worked at Radio Municipal, Alberto went to Spain, where he commited suicide in 1965. Arturo then moved to an apartment on Córdoba Avenue, between San Martin and Reconquista.

In his possession remained only a Rodin statuette, a lacquered commode from China, two Ming vases, an astonishing edition of Shakespeare's complete works, a portrait of Héctor Basaldúa, the complete works of Dickens, and a handful of friends.
He never missed a chance to give out presents, a generosity he displayed to his last days. He was in no position to gift emeralds, just small, luxury objects, almost always beyond the means of the recipient.

The Curtain Speaks

The curtain asked me for permission to say a few parting words. I could not deny her the honour. Here is verbatim what she told me:

"A hundred years seem like a lot, but time flies by and before you know it, rats! You are already old. I remember my birth, in between Rome and Paris. I still hear the steps of my creators, I feel the warmth of the Futurists as they helped my father concrete the project. Each line, each brushstroke made me striking. A circus scene is the first detail that catches everyone's attention. Not all of the characters belong to the circus, some belong to the fantastic world where winged creatures live, that is what makes me so special. In the background is Mount Vesuvius with all its energy, then the sea.

My life was evolving at warp speed until opening night. After that it remained placidly unchanged until I turned 22. I thought the exhibition in Buenos Aires was going to be just like any other, and yet. First came the trip. I had never endured such a long journey! And then, the war made me stay there for ten full years. This decade was paramount in my life. I got acquainted with the clean air of the Argentinian Pampas, and with a very special person, Arturito, my best friend. What a unique spirit! How sensitive! How cultured! If there is someone in this world who has made me feel truly appreciated, that was Arturo.

In America, from the darkness of the theatre I encountered the blinding light of the sun. From the urban crowds, I experienced the utter solitude of the countryside. I exchanged the whispers of the audience, for the conversation of the eucalyptus lining the main road to Aururito's estancia, La Melchora. Nevertheless, happiness is a fleeting affair. An exhibition returned me to Rome, my birthplace, and the daily routine. Thousands of people stopped over to see me, as in past exhibitions. Once it was over, a group of connoisseurs grew intent on altering my life path. I pretended not to care, yet, at times I grew worried about my future. I was at gorgeous La Scala. They took me one morning mid-way between a montage of a little known opera and the opening of Norma. In front of me there was an assorted group of curators representing different European museums. At one point someone with a French accent decided my future. Nobody

consulted me. It did not matter whether I wanted to remain by the shade of the eucalyptus, or whether I had to lie wrapped in storage in between exhibitions; my opinión never counted. I ended up in France, Paris, to be more precise and returned to the same circuit of non-stop exhibitions. My heart, however, stayed behind in the Argentinian Pampas.

Today Arturo is no longer here. I continue on my journey. The last stop for now, Rome, for my hundred years anniversary. I think I still have a long life ahead of me!"

WORLD-MAKING

Laury Leite
Mexico

Laury Leite (Mexico City, 1984), has published articles, essays, interviews, and chronicles in diverse literary magazines.
His stories have appeared in several anthologies. In 2017 he published *En la soledad de un cielo muerto* (Ediciones Carena; La Pereza Ediciones), his first novel, translated into English under *Night Has Fallen Here* (Lazy Publisher, 2019) and into Italian *Nella solitudine di un cielo morto*, Musicaos Editore, 2021). *La gran demencia*, his second novel, written with support from the Toronto Arts Council was published in Spain in 2020 (Huso Editorial). Laury is an alumni of the Banff Centre for Arts and Creativity. At present he is writing *El tiempo, el lugar y nosotros*, his third novel, with support from the Canada Council for the Arts and the Toronto Arts Council. He lives in Toronto, Canada.

Translation by Katie Fry

Katie Fry is a literary translator and post-secondary educator based in Toronto, Ontario. She received her PhD in Comparative Literature from the University of Toronto in 2017. Her translations include *Night Has Fallen Here* (2018) – the debut novel by Mexican-Canadian author Laury Leite – and the historical novel *Hochschild's Passports* (2019) by the celebrated Bolivian writer Verónica Ormachea. Her academic research has been published in *Mosaic: an Interdisciplinary Critical Journal*, *New Theatre Quarterly*, *Ivorian Journal of Comparative Studies*, and the edited collection *Fictional Worlds and Philosophical Reflection* forthcoming from Palgrave Macmillan (2022). She teaches courses in writing and literary studies at the University of Toronto and Sheridan College.

Museos invisibles

Mi lugar ideal

A principios de enero de 2020, regresé de un viaje que hice a Venecia para investigar el mito del origen en las obras de Giorgione, el pintor italiano de la escuela veneciana en el Alto Renacimiento. Una tarde, poco después de mi regreso, mi esposa me preguntó cuál era mi lugar ideal. Después de vacilar bastante, le dije que no había un solo lugar que reuniera todos los atributos que me gustan de los lugares que conozco, pero que quizá existía algo así como la ciudad continua de Calvino, una combinación de barrios y edificios de muchas ciudades, sobre todo europeas y americanas, que terminaría por formar en el territorio de mi imaginación una especie de lugar ideal. Una ciudad invisible.

Mi esposa rió, insatisfecha con mi respuesta, y en seguida me preguntó, con un tono de burla, si consideraba que mi desarraigo era tan extremo que no había ningún rincón en el vasto cosmos que pudiera considerar mi lugar ideal.

—Los museos —respondí sin pensarlo, a modo de defensa—. Mi lugar ideal son los distintos museos que he visitado.

Podría haber dicho nuestro departamento o la casa de mi madre, o una cabaña frente a un lago, pero no, dije: «museos». *Museos.*

Me detuve a pensar, como suelo hacer, en su etimología. La palabra museo viene del latín museum, que a su vez viene del griego moyseîon, que significa "templo y lugar dedicado a las musas." Nadie las ha visto pero todos hemos apreciado su influencia en tantas obras de arte, como el óleo de *La tempestad* de Giorgio Barbarelli que vi en mi viaje a Venecia. No solo las musas adquieren una dimensión tangible en las obras de arte que vemos en los museos, sino también el tiempo, ese fenómeno ambiguo y resbaladizo que no acabamos de entender y que se hace visible en los cuadros y en los objetos coleccionados y exhibidos en distintas galerías. Porque siempre que estamos ante una imagen estamos ante el tiempo. Concluí que los museos son mi lugar ideal porque los museos son la memoria del mundo.

—Pero ¿a qué museo te refieres? —volvió a la carga mi esposa,

riéndose de mí —No es lo mismo Bata Shoe Museum en Toronto, que solo exhibe zapatos, que el Museo del Prado en Madrid, que exhibe pinturas y esculturas.

Guardé silencio. Sospeché que si le decía la verdad, que si le hablaba del museo que había visto cerca de Venecia, hubiera pensado que estaba loco. Un aire incómodo quedó flotando en la sala. Me puse a observar por la ventana los edificios en el horizonte, las luces movedizas de los coches que subían y bajaban por la avenida y evité darle lógica a algo que no la tenía. Abrí el libro de Salvatore Settis sobre *La tempestad* de Giorgione, en la página 46, pero el croquis que quería mostrarle no estaba ahí. Dejé el libro en el librero y volví a mirar por la ventana de la sala de mi casa.

Mi esposa había vencido la partida de esa noche.

Sin desprender los ojos de los edificios en el horizonte, le respondí que no había un solo museo de los que conozco que reuniera todos los atributos que me gustan, pero que quizá existía algo así como un museo continuo, una combinación de pinturas y objetos de muchos museos, sobre todo europeos y americanos, que terminaría por formar, en el territorio de mi imaginación, una especie de museo ideal. Un museo invisible.

Mi esposa se quedó insatisfecha de mi respuesta y así pasamos la tarde dándole vueltas al asunto.

Gabinete de curiosidades I

Siempre me han fascinado los gabinetes de curiosidades, esos espacios enciclopédicos, tan populares entre los nobles y burgueses del Renacimiento, donde se coleccionaban objetos originales que venían de distintas partes del mundo. Sin embargo, no es el exotismo de las colecciones lo que me atrae. A fin de cuentas, la idea de lo exótico se vincula a la cultura y la mirada de quien observa el objeto, pero el objeto en sí no es exótico. Por razones biográficas, la mayoría de los objetos que llegaron a Europa desde el Nuevo Mundo no me resultan exóticos. Si los gabinetes de curiosidades o cuartos de las maravillas ejercen una verdadera fascinación sobre mí, es porque fueron los primeros espacios en trazar un puente imaginario entre América y Europa.

El viaje de Cristóbal Colón a América inició un periodo intenso de coleccionismo entre los europeos. La mirada que los exploradores (conquistadores, saqueadores) habían posado sobre aquellos territorios extraños se duplicaba, a una escala en miniatura, en los cuartos de las maravillas. El mundo lejano, reducido a su esencia, se arrastraba hasta Europa bajo la forma de unos cuantos objetos. En el microcosmos de los cuartos de las maravillas cabía el mundo entero y los visitantes podían repetir con los ojos, por el placer de mirar, las travesías de los exploradores en versión microscópica.

Muchos europeos saciaron su curiosidad científica y estética observando en los gabinetes de curiosidades colecciones de objetos que venían de las mal llamadas Indias Occidentales. A partir de 1519, los soldados de Hernán Cortés enviaron a Europa numerosos objetos expoliados a las civilizaciones indígenas. Tras la caída de Tenochtitlán, millares de tesoros aztecas —textiles, objetos de oro y plata, arte plumario y máscaras de jade— empezaron a inundar los palacios de los nobles europeos. El Mundus Novus, como lo definió Amerigo Vespucci en su carta a Lorenzo de Medici en 1503, tomó cuerpo en esos objetos que tanto maravillaron a los visitantes de los gabinetes de curiosidades en el Renacimiento.

Hacia 1520, Albrecht Dürer, el gran pintor alemán, cuyos ojos no dejan de seguirme en sueños desde que vi su autorretrato en el Museo del Prado de Madrid, escribió sus impresiones después de haber visto en un gabinete de Bruselas una serie de piezas procedentes del Tesoro de Moctezuma, que Hernán Cortés le había enviado a Carlos V. Se trata, quizá, de la primera observación del arte azteca por parte de un artista europeo. En la entrada de su diario del 27 de agosto de 1520, Dürer escribe:

> "Ví las cosas que le fueron traídas al Rey de la Nueva Tierra de Oro: un sol enteramente de oro de toda una braza de largo; asimismo una luna enteramente de plata del mismo tamaño; también varias curiosidades de sus armas, armaduras y proyectiles; vestidos muy extraños, mantas y toda clase de artículos raros de uso humano, todo lo cual es más bello de verse que maravilla. Estas cosas eran todas tan preciosas que estaban valuadas en cien mil florines. Pero nunca he visto en todos mis días nada que regocijara tanto a mi corazón como estas cosas. Pues ví entre ellas sorprendentes objetos de arte y me maravillé del sutil ingenio de los hombres de esas lejanas tierras."

En otra anotación de su diario, leí que también le impresionó una pequeña escultura de un fruto de jade. Él pensó que era una manzana, pero hoy sabemos que se trata de un Solanum lycopersicum: el fruto que en Italia llamaron pomo d'oro (manzana de oro), en Francia pomme d'amour (manzana del amor) y en España, conservando su raíz etimológica azteca, tomate.

Gabinete de curiosidades II

En Wikipedia hay una lista con los gabinetes de curiosidades más célebres de la historia: el de Carlos V de Francia; el studiolo de Gubbio; el celebérrimo studiolo de Isabella d'Este, decorado con pinturas de Andrea Mantegna; el Kunstkammer de Rodolfo II de Habsburgo, esa estancia donde coleccionaba sus obras de arte predilectas y que, en tantos sentidos, sentó las bases de lo que hoy conocemos como museo de arte.

Detesto ese modo jerárquico de describir la historia. Si hay algo que los gabinetes de curiosidades nos enseñan, es la certeza de que el mundo es un lugar extraño y desconocido, y que el conocimiento no es otra cosa que la búsqueda de lo maravilloso que oculta la naturaleza.

El museo invisible

En el tren de Milán a Venecia, en ese viaje que hice a principios de 2020, un tipo raro se sentó a mi lado. Tenía una barba canosa y la mirada azul. Llevaba puesto un abrigo un poco raído y un sombrero de copa reposaba en su regazo. A su lado, se podía ver la base de una jaula dorada cubierta con una tela negra. Cada tanto, se volteaba a verme y terminamos entablando una conversación. Hablamos un poco sobre mi viaje y cuando le mencioné que iba a Venecia para estudiar *La tempestad* de Giorgione, me dijo, muy efusivo, que debería darme una vuelta por el Palacio de Castelfranco, donde él vivía. Luego añadió que ahí había información, invaluable para el libro que estaba escribiendo. Me pidió una hoja para escribirme la dirección. Saqué el libro de Salvador Settis. El viajero extrajo una pluma fuente de plata de un bolsillo y dibujó en la página 46 un croquis con las instrucciones.

—No busques el palacio en ninguna guía —me dijo con un tono

entre siniestro y burlón mientras me devolvía el libro—: No lo vas a encontrar.

En la estación siguiente, se puso su sombrero de copa, sacó el papagayo que ocultaba dentro de la jaula dorada, y se despidió de mí. Lo tomé, como se suele tomar a la gente que interrumpe nuestro soliloquio, por un loco.

Una vez que llegué a Venecia, dejé mi maleta en el hotel —me habían asignado un cuartucho, oscuro y venido a menos, que daba a un callejón cerca del Ghetto judío— y di un largo paseo por una Venecia fría y brumosa. Me dejé arrastrar, como todos los viajeros en Venecia, sólo guiado por los ojos. Contemplé embelesado el vaivén del agua, la niebla movediza entre los edificios que emergían, como en un sueño, de las pequeñas ondas verdes de los canales. Todo lo que existía fuera de esa ciudad sublime podría haberse suprimido de mi memoria sin afectarme demasiado. En la carrera inexorable del olvido por borrarlo todo ya sólo quería rescatar a Venecia.

No fue sino hasta la noche que volví a pensar en el viajero del tren. Después de devorar unos spaghetti al pomodoro (bastante mediocres), el frío y el cansancio me empujaron a regresar a mi hotelucho. Todavía entregado a esa mezcla de euforia y fatiga que me había inundado el cuerpo con la extravagancia arquitectónica de una ciudad suspendida sobre el agua, estiré las piernas en la cama y abrí el libro de Salvatore Settis sobre *La tempestad* de Giorgione. Hojeando el libro entre un bostezo y otro, me tropecé con la antigua caligrafía del viajero en la página 46.

A la mañana siguiente, mientras tomaba un té en el restaurantucho del hotel y revisaba mis correos, se confirmaron mis sospechas. El palacio no aparecía en ninguna página de internet y la recepcionista del hotel nunca había escuchado hablar de él. Me reí de mi propia estupidez, sacudí la cabeza pensando en la locura en la que cae tanta gente y preparé mis cosas para ir a las Gallerie dell'Accademia al sur del Gran Canal. Finalmente, tras meses de estudios, lecturas y notas en la oscuridad de la biblioteca de la Universidad de Toronto, podría plantarme ante *La tempestad* y contemplar la figura de la mujer amamantando a su bebé, el hombre enigmático sosteniendo un asta al otro lado de un río, el relámpago en el cielo y la tormenta que los acecha. Tenía un deseo irreprimible de exponerme a sus colores auténticos, a su aquí y ahora.

El aura de la obra de Giorgione tuvo una influencia decisiva en mi experiencia estética. No era solo que los colores fueran más radiantes de cómo los había visto impresos en infinidad de libros, ni que los numerosos detalles del trabajo del pincel se me hubieran escapado en la planicie de las reproducciones. Lo que me había exaltado delante de la pintura de Giorgione era la densidad del fenómeno de duración, la presencia imborrable del tiempo y la estupefacción de tener ante mis ojos una serie de trazos, pintados quinientos años atrás, que habían dotado mi vida académica e intelectual de un destino, de una vocación. Debo confesar que en el baño de las galerías me asaltó la vanidad. Le robé una mirada a mi cara reflejada en el espejo y me deleité imaginando la envidia de mis colegas cuando vieran mi nombre impreso sobre la imagen de *La tempestad* en la portada de mi libro *Riders of the Storm: The Myth of Origin in Giorgione's Landscapes*. Unos turistas, que usaban mascarillas, se rieron de mí.

Después de dos semanas en Venecia, visitando iglesias y museos por las mañanas (cansado de los turistas que saturaban cualquier rincón de la ciudad) y escribiendo por las tardes en mi cuarto de hotel, me encontré atorado en una sección de mi libro que trataba específicamente sobre el pecado de Adán y Eva en *La tempestad*. Miré por la ventana el callejón soleado. La pintura de las paredes de ladrillos se caía a pedazos, las plantas estaban marchitas y el verdín avanzaba por los muros. Olía mal y a lo lejos sonaba en una vieja radio la narración de un partido de futbol, deporte que detesto con todas mis fuerzas. El paisaje gastado me empezaba a abrumar. Intenté retomar el capítulo del pecado original y recordé, no sin cierta aprensión, la risa amarga y desdeñosa del viajero en el tren, cuando le conté la base temática de mi libro, poco antes de que se pusiera serio y me recalcara que si me interesaban los orígenes de *La tempestad* debía visitar el Palacio de Castelfranco. Con el propósito de distraerme de mi trabajo, examiné el croquis en la página 46 del libro de Settis. El lugar no aparecía en Google Maps. La idea de que hubiera un punto ciego en la historia conocida de la vida de Giorgione me empezó a emocionar.

Llamé a Hertz (la que está cerca de la estación Venezia Santa Lucia) y renté un coche para la mañana siguiente. Sin demasiada esperanza, más por un afán de aventura que por otra cosa, atravesé la soleada Via della Libertà viendo de reojo los reflejos del sol en el agua y me dirigí a la provincia de Treviso. Cualquiera que haya visto alguna vez las pinturas de

Giorgione sabe de la belleza austera de la llanura padana, de la combinación del verde oscuro de los árboles en las colinas y el amarillo opaco de los prados.

Una vez que llegué a Castelfranco Véneto, seguí al pie de la letra las indicaciones que el viajero del tren me había escrito en la página 46 del libro de Settis. Pasé por unas colinas que bordeaban el pueblo y cuando llegué a la cuarta llanura, giré a la derecha y percibí que una enorme construcción de cristal sobresalía en el horizonte. Me asombró la facilidad con que encontré el palacio, y pensé que quizá me había equivocado de lugar.

Estacioné el coche cerca de un gran portal dorado. Una esquina de la construcción de cristal se veía entre las rejas y, más al fondo, la fachada del palacio. Toqué cinco veces una aldaba muy ornamentada y, poco después, surgió a lo lejos la figura del viajero del tren. Llevaba su sombrero de copa y el papagayo en el hombro. Me saludó con un gesto muy cordial y me abrió la puerta:

—Me alegro de que hayas venido —me dijo sin mirarme, con una voz monótona y nasal.

Caminamos en silencio hacia la construcción de cristal. Era un invernadero.

—Esto te puede interesar —soltó al dejarme pasar.

En el interior húmedo de esa especie de invernadero se conservaban millares de tomates amarillos y rojos, y en una pequeña placa, también dorada, había una inscripción que informaba que los Solanum lycopersicum (los tomates provenientes de América) se habían sembrado en Europa por primera vez justo en esa llanura del Véneto. Las semillas de los tomates amarillos y los rojos fueron lo único que Cósimo trajo del Nuevo Mundo, me dijo el viajero del tren dándole de comer un tomate a su papagayo. Las plantó al lado del museo que había fundado su padre, en honor de él y de su madre. Fue ahí donde Pietro Andrea Mattioli, en 1544, vio por primera vez esos frutos raros, que no había sabido reconocer Dürer en las esculturas aztecas, y les dio el nombre de Pomi d'oro.

—Bueno —continuó riendo el viajero— también trajo dos ardillas que dejó en Génova.

Todas las ardillas que ves correteando en Génova son americanas, como tú.

Tiró las sobras del tomate y metió al papagayo en su jaula dorada.

Su risa amarga y la impaciencia de no saber adónde iba me llevaron a preguntarle qué relación guardaba todo esto con Giorgione. Fingió no haberme oído y siguió mostrándome, sonriente y pausado, otras plantas americanas en el invernadero de cristal, que en ese momento, a causa de la abundancia del verdor y de los colores radiantes de las frutas colgando de las ramas, tomó ante mis ojos los matices de un paraíso perdido. Luego me dio un paseo por un herbario al lado del invernadero donde todavía había ejemplares originales de muchas plantas americanas que habían llegado a Europa en el siglo XVI. Se trataba, como el gabinete de curiosidades que vi después, de la colección de Andrea da Castelfranco, el padre de Cósimo.

La fachada del palacio propiamente dicho era blanca, revestida de mármol y tracería dorada. Al entrar en el atrio, el viajero me ofreció un café. Bajó al sótano a prepararlo y yo me quedé observando la magnitud del espacio. El viajero regresó con dos tacitas muy ornamentadas y nos pusimos a caminar por los distintos salones. Descubrí rápidamente que todo el palacio era un enorme gabinete de curiosidades, una especie de laberinto renacentista, un museo infinito repleto de pinturas y objetos europeos y americanos. En las paredes había cuadros de Bellini, Tiziano y Tintoretto, y en varios muebles de madera se exponían tesoros aztecas, fósiles, piedras, animales disecados, máscaras de jade, penachos y esculturas de todo tipo. Cada salón tenía el nombre de un órgano del cuerpo humano. Recuerdo con especial turbación el llamado Salón de las lenguas, donde se conservaban en formol las lenguas reales —los órganos, quiero decir— de varios guerrilleros aztecas. En una bóveda del Salón de los corazones, en el centro del palacio (donde había una cama y muebles con corazones disecados) alcé la mirada y percibí una infinidad de frescos desgastados de Giorgione. El viajero me señaló la pared, enfrente de la cama, donde colgaba la pintura original de Giorgione que me quería mostrar. "Esto puede ser útil para tu investigación" me dijo. La pintura era casi idéntica a *La tempestad*, pero trataba de forma más carnal el tema de Adán y Eva antes de su expulsión del paraíso. Las figuras de Eva y Adán aparecían desnudas e irradiaban serenidad y alegría. En el árbol había frutos jugosos,

y la tormenta, a lo lejos, parecía acechar en esta pintura de un modo, si cabe, todavía más ominoso.

El viajero me comentó que Giorgione había usado a los tres miembros de la familia Castelfranco como modelos y acto seguido me contó la historia de la familia. Resulta que Andrea da Castelfranco le comisionó un cuadro sobre el pecado original a Giorgione, que era un amigo íntimo suyo desde la infancia. Andrea quería que el cuadro se llamara *Pecado original*, pero Giorgione, más tolerante, lo llamó *El origen* y se sirvió de ese nuevo título para usar como modelos a Andrea, a Dorotea; su hermana gemela, y a Cósimo; su bebé de algunos meses. Poco después de que Giorgione pintara el cuadro, se descubrió que Andrea da Castelfranco había mantenido relaciones sexuales con Dorotea y empezó a circular el rumor de que Cósimo era su hijo. Cuando el esposo de Dorotea descubrió la pintura y vio a los tres desnudos, Dorotea desapareció. Andrea, temeroso del destino que le podía esperar a Cósimo, lo raptó y lo mandó con un amigo de Giorgione, primero a Génova, luego a España y de ahí al Nuevo Mundo en la flota de Alonso Quintero. Tras la conquista de La Española, Hernán Cortés se hizo cargo de él y Cósimo, ya como adolescente, lo acompañó en su expedición a lo que hoy conocemos como México. Gracias a una carta que le escribió el amigo de Giorgione, Cósimo se enteró de la historia de sus padres y siempre soñó con retornar al palacio.

Mientras tanto, Andrea da Castelfranco construyó el gabinete de curiosidades más grande de Europa en honor de su hijo y de su hermana gemela desaparecida. Se dedicó a coleccionar, de modo obsesivo, todo tipo de plantas y obras de arte provenientes de América. Era la única manera que tuvo de imaginarse la vida del pequeño Cósimo en el Nuevo Mundo y también de rendirle tributo a la memoria de su hermana gemela desaparecida.

Alrededor de 1504, la familia Vendramin le comisionó un cuadro a Giorgione. Zorzi, como le decía de cariño Andrea, pintó otra versión de El origen, que llamó: *La tempestad*, en el gabinete de Andrea, donde trabajaba en los frescos del Salón de los corazones, y esa pintura, una copia casi calcada de la otra, es la que ahora está en la sala de las Gallerie dell'Accademia. Hay algunas diferencias, pero no cabe duda, los modelos son los mismos: Andrea, Dorotea y Cósimo.

Unos años más tarde, según me contó el viajero, Andrea da Castelfranco abandonó su palacio y huyó en un barco de Génova al Nuevo Mundo en busca de su hijo. Nunca volvió a Europa. Los caprichos de la historia quisieron que casi al mismo tiempo Cósimo hiciera el trayecto inverso y zarpara en un barco en el puerto de Veracruz, con un par de ardillas y las semillas de tomate en los bolsillos, hacia Europa en busca de su padre.

Una especie de dama de compañía de Isabella d'Este le contó a Cósimo que cerca de Castelfranco había un palacio abandonado. Cósimo lo encontró y decidió plantar las semillas de tomate enfrente del palacio, justo debajo del Salón de los corazones donde estaba abandonado *El origen*, el cuadro de Giorgione.

Hacia el final de mi visita el viajero me llevó al jardín trasero. Era el mismo jardín que aparecía en *El origen* y *La tempestad* de Giorgione. El viajero rió al comprobar mi asombro. Poco después aseguró, con ese tono monótono y nasal que el gabinete de Castelfranco era el museo de arte más antiguo de la historia. El primer museo. Un instante después, me ofreció otro café. Lo rechacé con un gesto de agradecimiento. Caminamos en silencio hacia el invernadero, atravesando el huerto de tomates y la jaula dorada del papagayo. No sé cómo hasta entonces no se me había ocurrido preguntarle su nombre. Con la misma sonrisa pícara del tren, me contestó que se llamaba Cósimo. Quise preguntarle cómo era posible que el primer museo de la historia no apareciera en ningún mapa, pero cuando iba a abrir la boca, Cósimo me extendió la mano dándome a entender que la visita había finalizado y me felicitó por haberme atrevido a ir a su Palacio de Castelfranco. Nadie más lo había hecho.

Cuando devolví el coche en Venecia, vi el libro de Settis en el asiento de copiloto. Lo abrí y noté que alguien había borrado el croquis de la página 46. Quizá sea mejor así. Si hay algo que los gabinetes de curiosidades nos enseñan es la certeza de que el mundo es un lugar extraño y desconocido, y que el conocimiento no es otra cosa que la búsqueda de lo maravilloso que oculta la infinita naturaleza.

La peste

Terminé un borrador de un capítulo del libro sobre el mito del origen en la obra de Giorgione la mañana en que impusieron el primer confinamiento en Toronto por el coronavirus. Pensé en la extraña coincidencia que me regalaba la historia. El capítulo trataba sobre los últimos días de Giorgione. Un par de años después de que pintara *La tempestad*, Giorgione murió en Venecia a causa de la peste. El miedo y la incertidumbre de esa época encontraba una resonancia histórica con lo que sucedía a mi alrededor. La pandemia trazaba otro puente imaginario entre la Venecia del siglo XVI y Canadá en el siglo XXI.

Después de almorzar, mi esposa y yo teníamos pensado ir al Art Gallery of Ontario para ver una exposición de fotografías de Diane Arbus, pero por las restricciones tuvimos que cancelar el plan. Mi esposa, para pasar el rato, me preguntó cuál había sido la experiencia más intensa que había vivido en un museo. Me decidí finalmente a contarle sobre el gabinete de Castelfranco. Le describí *El origen*, la pintura de Giorgione, y el encuentro con Cósimo. Me pidió con una expresión incrédula que le mostrara fotos. Le dije que no le había tomado fotos, me había parecido obsceno sacar el celular de la nada y robarme su retrato. Recuerdo que una vez intenté sacarle una foto a un muchacho Tarahumara en Chihuahua y me lo impidió argumentando que las cámaras le robaban el alma a la gente. No creo que tengamos un alma (suficiente tenemos con el cuerpo), pero desde entonces dejé de tomarle fotos a la gente. Mi esposa rió y me respondió que no me creía. Siempre he sido así. Sólo me gustan las cosas invisibles. Mi lugar ideal, lo sé ahora, es un museo invisible.

Invisible Museums
Translation by Katie Fry

My Ideal Place

In early January 2020, I returned from a trip I took to Venice to research the myth of origin in the works of Giorgione, the Italian painter of the High Renaissance Venetian school. One evening, shortly after my return, my wife asked me what my ideal place was. After hesitating for some time, I told her there was no one place that brought together all the attributes I like about the places I've been to, but that perhaps there was something like Calvino's continuous city, a combination of neighbourhoods and buildings from many cities, especially European and American ones, that would end up forming a kind of ideal place in the territory of my imagination. An invisible city.

My wife laughed, dissatisfied with my answer, and then asked me in a teasing tone of voice if my rootlessness was so extreme that there was nowhere in the vast cosmos that I might call my ideal place.

"Museums," I answered without thinking, by way of defence. "My ideal place is the different museums I've visited."

I could have said our apartment. Or my mother's house. Or a cottage on the lake. But no, I said "museum." *Museum.*

I paused to think, as I tend to do, about its etymology. The word museum comes from the Latin museum, which in turn comes from the Greek moyseîon, which means "temple and place dedicated to the Muses." No one has seen them, but we've all appreciated their influence on so many works of art, such as the oil painting *The Tempest* by Giorgio Barbarelli that I saw on my trip to Venice. Not only the Muses acquire a tangible dimension in the works of art we see in museums, but also time, that ambiguous and slippery phenomenon we're not able to fully understand, becomes visible in the paintings and objects collected and displayed in different galleries. Because whenever we are before an image, we are before time. I concluded that museums were my ideal place because museums are the memory of the world.

"But which museum are you referring to?" retorted my wife, laughing at me. "The Bata Shoe Museum in Toronto, which only displays shoes, and the Prado Museum in Madrid, which displays paintings and sculptures, are not the same thing."

I kept silent. I was afraid that if I told her the truth, if I told her about the museum I had seen near Venice, she would think I was crazy. An air of discomfort hung in the room. I looked out the window at the skyline, at the moving lights of the cars going up and down the avenue, and I gave up my attempt to ascribe logic to something that had none. I opened the book by Salvatore Settis on Giorgione's *The Tempest* to page forty-six, but the sketch I wanted to show her wasn't there. I put the book back on the shelf and looked out my living-room window again.

My wife had won that evening's game.

Without taking my eyes off the skyline, I replied that there was no one museum that brought together all the attributes I like about the museums I've been to, but that perhaps there was something like a continuous museum, a combination of paintings and objects from many museums, especially European and American ones, that would end up forming a kind of ideal museum in the territory of my imagination. An invisible museum.

My wife was still dissatisfied with my answer, and we spent the afternoon that way, talking in circles.

Cabinet of Curiosities I

I've always been fascinated by cabinets of curiosities, those encyclopedic spaces, so popular among the nobility and the bourgeoisie of the Renaissance, where original objects hailing from different parts of the world were collected. It's not the exoticism of the collections that attracts me, though. Ultimately, exoticism lies in the culture and the gaze of the one observing an object, not in the object itself. For biographical reasons, most of the objects that came to Europe from the New World don't appear exotic to me. If cabinets of curiosity or wonder rooms exert a real fascination over me, it's because they were the first spaces to draw an imaginary bridge between America and Europe.

Christopher Columbus's voyage to America inaugurated an intense period of collecting among Europeans. The gaze that the explorers (conquerors, plunderers) had fixed on those strange lands was duplicated, on a miniature scale, in the wonder rooms. The distant world, reduced to its essence, was brought to Europe in the form of a few objects. The entire world fit inside the microcosm of the wonder rooms, and visitors could repeat with their eyes, for the sheer pleasure of looking, a microscopic version of the explorers' voyages.

Many Europeans satiated their scientific and aesthetic curiosity by observing, in the cabinets of curiosities, collections of objects that came from the misnamed West Indies. From 1519 onwards, Hernán Cortés's soldiers sent numerous shipments of objects plundered from Indigenous civilizations to Europe. After the fall of Tenochtitlan, thousands of Aztec treasures—textiles, gold and silver objects, feather handicrafts and jade masks—began to flood the palaces of European nobles. The Mundus Novus, as Amerigo Vespucci defined it in his letter to Lorenzo de Medici in 1503, took shape in the objects that so enchanted those who visited the cabinets of curiosities in the Renaissance.

Around 1520, Albrecht Dürer, the great German painter whose eyes have been following me in dreams ever since I saw his self-portrait in the Prado Museum in Madrid, wrote his impressions after having seen, in a cabinet in Brussels, a series of pieces from the Treasure of Moctezuma that Hernán Cortés had sent to Charles V. This is, perhaps, the first observation of Aztec art by a European artist. In his diary entry of August 27, 1520, Dürer writes:

> I saw the things which have been brought to the King from the new land of gold, a sun all of gold a whole fathom broad, and a moon all of silver of the same size, also two rooms full of armour of the people there, and all manner of wondrous weapons of theirs, harness and darts, very strange clothing, beds, and all kinds of wonderful objects of human use, much better worth seeing than prodigies. These things were all so precious that they are all valued at 100,000 florins. All the days of my life I have seen nothing that rejoiced my heart so much as these things, for I saw amongst them wonderful works of art, and I marvelled at the subtle ingenuity of men in foreign lands.

I read, in another diary entry, that he was also struck by a small sculpture of a jade fruit.

He thought it was an apple, but today we know that it was a Solanum Lycopersicum, the fruit they called pomo d'oro (golden apple) in Italy, pomme d'amour (apple of love) in France, and, in Spain, preserving its etymological Aztec root, tomate (tomato).

Cabinet of Curiosities II

On Wikipedia there's a list of the most famous cabinets of curiosities in history: that of Charles V of France; the studiolo of Gubbio; the universally renowned studiolo of Isabella d'Este, decorated with paintings by Andrea Mantegna; the Kunstkamme*r* of Rudolf II of the House of Habsburg, the room where he kept his favourite works of art and which, in so many ways, laid the foundations for what we now call an art museum.

I detest this hierarchical way of describing history. If there's one thing that cabinets of curiosity teach us, it's the certainty that the world is a strange and unknown place, and that knowledge is nothing more than the search for the marvelous hidden in nature.

The Invisible Museum

On the train from Milano to Venice, on the trip I took at the beginning of 2020, a strange man sat down beside me. He had a gray beard and blue eyes. He was wearing a somewhat tattered coat and a top hat rested on his lap. The base of a golden cage covered with a black cloth could be seen beside him. Every so often he would turn to look at me, and we ended up starting a conversation. We talked a bit about my trip, and when I mentioned that I was going to Venice to study Giorgione's *The Tempest* he said, quite effusively, that I should stop by Castelfranco Palace, where he lived. He then added that I would find invaluable information there for the book I was writing. He asked for a piece of paper to write down the address for me; I took out Salvador Settis's book. The traveler pulled a silver fountain pen out of his pocket and drew a sketch with directions on page forty-six.

"Don't look for the palace in any guidebook," he said in a partly sinister, partly mocking tone of voice as he handed back the book. "You won't find it."

At the next station, he put on his top hat, took out the parrot he was hiding in the golden cage, and said goodbye to me. I took him, as we tend to take people who interrupt our silent soliloquy, for a madman.

When I arrived in Venice, I left my suitcase at the hotel—I'd been assigned a dark, shabby little room overlooking an alleyway near the Jewish Ghetto—and took a long walk through a cold and foggy Venice. I let myself be carried away, like all travelers in Venice, guided only by my eyes. I gazed spellbound at the swaying of the water, the restless fog between the buildings that emerged, as if in a dream, from the small green ripples of the canals. Everything that existed outside of this sublime city could have been erased from my memory without doing me much harm. In the inexorable race of oblivion to erase everything, I only wanted to save Venice.

It wasn't until evening that I thought about the train traveler again. After devouring some spaghetti al pomodoro (rather mediocre), the cold and fatigue propelled me to return to my shabby little hotel. Still given over to that mixture of euphoria and exhaustion that had flooded my body at the architectural extravagance of a city hanging suspended over water, I stretched out my legs on the bed and opened Salvatore Settis's book on Giorgione's *The Tempest*. Leafing through the book between yawns, I stumbled upon the traveler's old-fashioned handwriting on page forty-six.

The next morning, as I was having tea in the shabby little hotel restaurant and checking my email, I thought my suspicions had been confirmed. The palace didn't appear on any website, and the hotel receptionist had never heard of it. I laughed at my own stupidity, shook my head thinking about the madness into which so many people descend, and got ready to go to the Gallerie dell'Accademia south of the Grand Canal. Finally, after months of studying, reading, and taking notes in the darkness of the University of Toronto library, I would be able to stand before *The Tempest* and contemplate the figure of the woman nursing her baby, the enigmatic man holding a staff on the other side of the river, the lightning in the sky and the storm lying in wait. I had an irrepressible desire to expose myself to its authentic colours, to its here and now.

The aura of Giorgione's work had a decisive influence on my aesthetic experience. It wasn't just that the colours were more radiant than they had appeared printed in countless books, or that the many details of the brushwork had escaped me in the flatness of the reproductions. What exhilarated me in front of Giorgione's painting was the density of the phenomenon of duration, the indelible presence of time and the stupefaction at having before my eyes a series of strokes, painted five hundred years ago, that had endowed my academic and intellectual life with a destiny, a vocation. I must confess that in the gallery washroom I was assailed by vanity. I stole a glance at my face reflected in the mirror, and I delighted in imagining the envy of my colleagues when they saw my name printed over the image of *The Tempest* on the cover of my book *Riders of the Storm: The Myth of Origin in Giorgione's Landscapes*. Some tourists wearing face masks laughed at me.

After two weeks in Venice, visiting churches and museums in the mornings (weary of the tourists saturating every corner of the city) and writing in my hotel room in the afternoons, I found myself stuck on a section of my book dealing specifically with the sin of Adam and Eve in *The Tempest*. I looked out the window at the sun-filled alleyway. The paint on the brick walls was peeling off, the plants were wilted, and verdigris was creeping over the walls. It smelled bad and, in the distance, an old radio was playing the commentary for a soccer match, a sport I detest with every fibre of my being. The tired landscape was beginning to weigh on me. I tried to go back to the chapter on original sin and recalled, not without some apprehension, the bitter and disdainful laughter of the traveler on the train when I told him the thematic basis of my book, shortly before he became serious and stressed that if I was interested in the origins of *The Tempest* I should visit Castelfranco. To distract me from my work, I examined the sketch on page forty-six of Settis's book. The place didn't appear on Google Maps. The idea that there was a blind spot in the known history of Giorgione's life began to excite me.

I called Hertz (the one near Venezia Santa Lucia Station) and rented a car for the next morning. Without much hope, more from a desire for adventure than anything else, I drove down the sunny Via della Libertà, glancing at the reflection of the sun on the water out of the corner of my eye, and headed towards the province of Treviso. Anyone who has ever seen Giorgione's paintings knows of the austere beauty of the Padan Plain, the

combination of the dark green of the trees on the hills and the opaque yellow of the meadows.

Once I arrived in Castelfranco Veneto, I followed the directions the train traveler had written down for me on page forty-six of Settis's book to the letter. I passed some hills bordering the town, and when I arrived at the fourth plain, I turned right and spotted a huge glass structure towering over the horizon. I was amazed at the ease with which I found the palace and thought I might have arrived at the wrong place.

I parked the car near a large golden gate. A corner of the glass structure could be seen between the bars and, further back, the palace façade. I rapped an ornate door knocker five times and, shortly afterwards, the silhouette of the train traveler appeared in the distance. He was wearing his top hat and the parrot was resting on his shoulder. He greeted me very cordially and opened the gate.

"I'm glad you came," he said in a monotone, nasal voice without looking at me. We walked in silence towards the glass structure. It was a greenhouse.

"This might interest you," he said as he let me pass.

In the humid interior of that sort of greenhouse were kept thousands of yellow and green tomatoes, and on a small plaque, also golden, there was an inscription stating that the Solanum lycopersicum (tomatoes from America) had been planted in Europe for the first time on that plain in the Veneto. The seeds from yellow and red tomatoes were all that Cosimo brought back from the New World, the train traveler said, feeding a tomato to his parrot. He planted them beside the museum his father had founded, in honour of him and his mother. That's where Pietro Andrea Mattioli, in 1544, saw these strange fruits for the first time, the ones that Dürer hadn't been able to recognize in the Aztec sculptures, and gave them the name Pomi d'oro.

"Well," the traveler continued, laughing, "he also brought two squirrels that he left in Genoa. All the squirrels you see running around Genoa are American, like you."

He threw away the tomato scraps and put the parrot in its golden cage.

His bitter laughter and my impatience at not knowing what he was getting at led me to ask him what all this had to do with Giorgione. He pretended he hadn't heard me and continued showing me, smiling and unhurried, other American plants in the glass greenhouse, which at that moment, due to the abundance of greenery and the radiant colours of the fruits hanging from the branches, took on the hue of a lost paradise before my eyes. He then gave me a tour of an herbarium next to the greenhouse that still housed original specimens of many American plants brought to Europe in the sixteenth century. It was, like the cabinet of curiosities I saw afterwards, the collection of Andrea de Castelfranco, Cosimo's father.

The façade of the palace itself was white, lined with marble and gilded tracery. As we entered the atrium, the traveler offered me a coffee. He went down to the basement to prepare it, and I remained, observing the magnitude of the space. The traveler returned with two tiny ornate cups, and we began to walk through the various halls. I quickly came to realize that the entire palace was one giant cabinet of curiosities, a sort of Renaissance labyrinth, an infinite museum filled with European and American paintings and objects. On the walls hung paintings by Bellini, Titian, and Tintoretto, and on various pieces of wooden furniture were displayed Aztec treasures, fossils, stones, preserved animals, jade masks, plumes, and sculptures of all kinds. Each hall was named after an organ of the human body. I remember with particular bewilderment the so-called Hall of Tongues, where the real tongues—the organs, I mean—of several Aztec warriors were preserved in formaldehyde. In the vault of the Hall of Hearts, at the centre of the palace (where there was a bed and furniture with dried hearts), I looked up and saw an infinity of faded frescoes by Giorgione. The traveler pointed to the wall, in front of the bed, where the original painting by Giorgione that he wanted to show me hung. "This might be useful for your research," he said. The painting was almost identical to *The Tempest*, but it dealt in a more carnal way with the theme of Adam and Eve before their expulsion from paradise. The figures of Eve and Adam appeared naked, and they radiated joy and serenity. Juicy fruits hung from the tree, and the storm in the distance seemed to threaten even more ominously in this painting, if that's possible.

The traveler told me that Giorgione had used the three members of the Castelfranco family as models, and immediately afterwards he told me the family's story. It seems that Andrea da Castelfranco commissioned a painting on original sin from

Giorgione, who had been a close friend of his since childhood. Andrea wanted the painting to be called *Original Sin*, but Giorgione, who was more moderate, called it *The Origin*, and this new title allowed him to use Andrea; Dorotea, his twin sister; and Cosimo, her two-month-old baby, as models. Shortly after Giorgione painted the picture, it came to light that Andrea de Castelfranco had had sexual relations with Dorotea, and the rumour that Cosimo was his son began to circulate. When Dorotea's husband discovered the painting and saw the three of them naked, Dorotea disappeared. Andrea, fearful of the fate that might await Cosimo, kidnapped him and sent him with a friend of Giorgione's, first to Genoa, then to Spain, and from there to the New World in Alonso Quintero's fleet. After the conquest of Hispaniola, Hernán Cortés took him under his wing and Cosimo, now a teenager, accompanied him on his expedition to what we now call Mexico. Thanks to a letter sent to him by Giorgione's friend, Cosimo learned of his parents' story and always dreamed of returning to the palace.

In the meantime, Andrea da Castelfranco built the largest cabinet of curiosities in Europe in honour of his son and his missing twin sister, dedicating himself obsessively to the collection of all kinds of plants and works of art from America. It was the only way he could imagine the life of little Cosimo in the New World and also pay tribute to the memory of his missing twin sister.

Around 1504, the Vendramin family commissioned a painting from Giorgione. Zorzi, as Andrea affectionately called him, painted another version of *The Origin*, which he called *The Tempest*, in Andrea's cabinet where he was working on the frescoes in the Hall of Hearts, and that painting, practically a carbon copy of the other, is the one that now hangs in the Gallerie dell'Accademia. There are several differences, but the models are undoubtedly the same: Andrea, Dorotea, and Cosimo.

A few years later, as the traveler told me, Andrea da Castelfranco left his palace and fled to the New World in search of his son on a ship from Genoa. He never returned to Europe. The vagaries of history would have it that, at almost the same time, Cosimo made the reverse journey, setting sail for Europe from the port of Veracruz, with a couple of squirrels and tomato seeds in his pockets, in search of his father.

A sort of lady-in-waiting of Isabelle d'Este told Cosimo about

an abandoned palace near Castelfranco. Cosimo found it and decided to plant the tomato seeds in front of the palace, right below the Hall of Hearts where *The Origin*, Giorgione's painting, had been left behind.

Towards the end of my visit, the traveler took me to the rear garden. It was the same garden that appeared in Giorgione's *The Origin* and *The Tempest*. The traveler laughed at my amazement. Shortly afterwards he assured me, in his monotone, nasal voice, that the cabinet of Castelfranco was the oldest art museum in history. The first museum. A moment later, he offered me another coffee. I declined with a gesture of gratitude. We walked in silence towards the greenhouse, passing by the tomato plants and the parrot's golden cage. I don't know how it hadn't occurred to me until then to ask his name. With the same mischievous grin he had given me on the train, he replied that his name was Cosimo. I wanted to ask him how it was possible that the first museum in history didn't appear on any map, but when I was about to open my mouth Cosimo extended his hand, making it understood that the visit had come to an end, and congratulated me for having dared to come to his palace at Castelfranco. No one else had ever done so.

When I returned the car in Venice, I saw Settis's book on the passenger seat. I opened it and noticed that someone had erased the sketch on page forty-six. Perhaps it's better that way. If there's one thing that cabinets of curiosity teach us, it's the certainty that the world is a strange and unknown place, and that knowledge is nothing more than the search for the marvelous hidden in infinite nature.

The Plague

I finished a draft of a chapter of my book on the myth of origin in Giorgione's work the morning that the first Coronavirus lockdown was imposed in Toronto. I thought about the strange coincidence that history had gifted me with. The chapter was about Giorgione's last days. A few years after he painted *The Tempest*, Giorgione died in Venice from the plague. The fear and uncertainty of that historical period resonated with what was going on around me. The pandemic drew another imaginary bridge between sixteenth-century Venice and twenty-first century Canada.

After lunch, my wife and I had planned to go to the Art Gallery of Ontario to see an exhibit of Diane Arbus's photographs, but we had to cancel our plans due to the restrictions. To pass the time, my wife asked me what the most intense experience I'd ever had in a museum was. I finally decided to tell her about the cabinet at Castelfranco. I described *The Origin*, Giorgione's painting, and meeting Cosimo. With a look of incredulity, she asked me to show her pictures. I told her I hadn't taken any pictures, it had seemed obscene to me to take out my phone all of a sudden and snap a picture of him. I remember I once tried to take a picture of a Tarahumara boy in Chihuahua and he stopped me, arguing that cameras steal people's souls. I don't think we have a soul (our bodies are quite enough), but since then I've stopped taking pictures of people. My wife laughed and replied that she didn't believe me. I've always been that way. I only like invisible things. My ideal place, I now know, is an invisible museum.

Liuba González de Armas
Cuba

Shouts on the Wall, Echoes in the Archive

A poster is a printed image designed to catch the eye, to persuade by visual shout or whisper. A poster is an ephemeral thing; its voice and urgency are rooted in a specific time and space. A well-made poster nonetheless finds its way onto a wall well after its original purpose is served, and Cuban posters exemplify this feature well.

I do not remember the first time I saw a Cuban poster, just as I do not remember the first time I ate a guava, or smelled tobacco smoke, or felt summer rain. I would like to believe these graphics were a vibrant and indelible part of my childhood home, but the truth is my memory of Cuba is that of a child of the 1990s, which is to say that there were other priorities.

I do, however, remember the first time I encountered the Cuban poster as an idea: in a seminar about public art in North America taught by the esteemed Prof. Betsy Boone at the University of Alberta in early 2016. This essay is a rumination on diaspora and the afterlives of Cuban posters as emigrating objects. I write from my experience as a diasporic Cuban visual culturist troubled by how the outward flow of these historical graphics impacts their availability to Cubans on the island.

When I speak of Cuban revolutionary posters, I am referring to state-commissioned public images produced in Cuba starting in the 1960s. After the revolutionary victory of 1959, the Cuban government adopted a policy of mass communication through silkscreen and offset posters. These images played complementary roles as vehicles for mass communication and aesthetic objects, conveying messages about the Revolution and its values through their content and form. The height of production and critical acclaim for these graphics roughly spanned from 1962 to 1975, a period that scholars of Cuban design have historicized as the Golden Age of Cuban posters. By giving visual form to pressing social questions of the revolutionary era, these posters facilitated the development of a contemporary Cuban visual culture independent from commercial interests which had dominated earlier graphics.

Even miniaturized and altered by the electronic glow of my laptop screen, these images had a magnetic hold on me. I was captivated by their bold colours, the certainty of lines, the vitality and visual punch with which they delivered their

messages. The sheer range of visual forms and styles articulated in these images fascinated me. I learned to discern the dynamic Pop Art sensibility of Raúl Martinez from the baroque whimsy of [Eduardo Muñoz] Bachs, the minimalist wit of Félix Beltrán, and the dynamic compositions of Alfredo Rostgaard.

Though Cuban posters are often treated as a unit, these graphics are far from homogenous in their production, networks of distribution, and purpose and intended audiences. The three principal producers of Cuban revolutionary posters were the national film board (Instituto Cubano del Arte e Industria Cinematográficos, or ICAIC, f. 1959), the Department of Revolutionary Orientation (DOR, formerly the Comisión de Orientación Revolucionaria, f. 1962), and the Organization of Solidarity with the People of Asia, Africa, and Latin America (OSPAAAL, f. 1966). These institutions varied in their aims, structures, and proximity to the state and its oversight. ICAIC, DOR, and OSPAAAL respectively produced film posters, public service and political materials, and international political propaganda. Posters were distributed and displayed through networks of bulletin boards across public spaces, including schools, hospitals, factories, and the offices of mass organizations. With the exception of internationalist graphics produced by OSPAAAL, these images were intended for a domestic audience. Nonetheless, they circulated in transnational networks that transcended the geopolitical boundaries of the Cold War.

My first time researching Cuban posters onsite in an archive was in the spring of 2018. I was a recent Art History graduate interested in revolutionary representations of women and armed with a research stipend: enough to cover a return flight, a room rental at a casa particular, and expenses for a month in Havana. A preliminary search led me to the National Library (Biblioteca Nacional José Martí, or BNJM) in Havana, which holds the most comprehensive collection of Cuban posters in Latin America.[17] The BNJM is a stately modernist building just off Plaza de la Revolución. The grand marble-lined lobby, with its high ceiling and Art Deco stained-glass oculus, evokes the old glamour of 1950s Cuba with scholarly decorum. I arrived with undisguised eagerness, the air conditioning quickly cooled beads of perspiration that had begun to settle on my temples

[17] Laura Susan Ward, "A Revolution in Preservation: Digitizing Political Posters at the National Library of Cuba," *IFLA Journal 31*, no. 3 (October 2005): 260–67.

from walking in the morning sun. The receptionist, sensing my inexperience, patiently guided me through the paperwork for a membership card. Once inside the reading room, I set about locating the materials on my list.

Upon inquiring about these with the librarian on duty, I was swiftly faced with an unexpected fact: the national poster collection was in dire condition. The BNJM faced severe under-resourcing brought about by decades of economic strain aggravated by the ongoing U.S. embargo on Cuba. Limited access to the materials necessary to maintain climate-controlled facilities means that the posters, which were not designed to last forever, are subject to decay in Cuba's tropical climate. As a preservative measure, the library's administration has opted to limit public access to the collection. Instead, the BNJM offers researchers use of some six thousand digital reproductions of posters, stored in a series of numbered compact discs.

This essay emerged from my perplexity upon finding that through the vicissitudes of half a century of collecting and archiving shaped by the Cold War, globalization, and the flow of capital, accessing original Cuban posters today is more feasible in parts of the United States than it is in Cuba. Dispersed over university libraries and private collections in Los Angeles, New York, San Francisco, Albuquerque, and Pittsburgh, among others, Cuban revolutionary posters have become decidedly diasporic.

I recognize the irony of lamenting this migration. As a child immigrant, I developed an understanding of my homeland from a distance. I was formed as a Cubanist in the diaspora. Indeed, living and studying in Canada has granted me access to financial capital, mobility, and institutional resources and archives that I would not have had in Cuba. This knowledge troubles me. When I see these posters, I recognize my own diasporic distance. I am close enough to bristle at the thought of a Gringo treating these historic objects as mere souvenirs of their latest Winter getaway to Varadero, but far enough to benefit from their acquisition by North American archives. My concern over the presence of Cuban revolutionary posters, as fellow emigrants, in North America prompts me to ask:

1 How did Cuban revolutionary posters reach North America?
2 What did (and do) they signify for people here?
3 How does the flow of Cuban posters to North America impact Cubans' access to them today?

I look for answers to these questions in texts that illustrate patterns of appraisal, collection, and exhibition of Cuban posters in North America since the late 1960s. I focus on the historical, but extend some observations to the present moment. This period spans only a fraction of the history of Cuban posters in North America, but it does coincide with heightened interest in revolutionary visual culture in the U.S. as social movements of the 1960s extended into the 1970s. Three interrelated threads shape my discussion: Cuban public diplomacy, North American (political) tourism in Cuba, and visual co-optation.

How did Cuban posters reach North America?

The U.S. government perceived the Cuban Revolution of 1959 as a threat to its hemispheric hegemony and sought to contain it by restricting travel and trade with Cuba beginning in the early 1960s. On January 3, 1961, the U.S. broke diplomatic relations with Cuba, declaring its citizens' travel to Cuba contrary to national security interests. U.S. Americans wishing to visit the island nation required passport endorsement from the State Department, which were available only in limited circumstances that excluded tourism and research. On September 4, 1961, Congress enacted the *Foreign Assistance Act,* which set a total embargo on trade between the two nations. On February 7, 1962, President John F. Kennedy prohibited virtually all imports from Cuba. Subsequent decisions in March and May of the same year made it illegal to import products of Cuban origin from any part of the world; this ban extended to materials brought into the country by returning U.S. American tourists. While the Supreme Court rebuffed efforts to prosecute those travelling to Cuba without passport endorsements in 1967, visitors were still subject to the established trade sanctions.

Despite legal restrictions on trade and travel to the island, Cuban posters entered the United States throughout the 1960s and 70s in myriad ways. The ubiquity of revolutionary posters in Cuba meant U.S. visitors were likely to encounter these images and document them through photographs, and written and oral accounts of their travels. Collected as souvenirs, research materials, or consciousness-raising tools alongside Cuban films and other publications, posters were imported both clandestinely and under State Department licenses by individuals and institutions. Access to Cuban posters was not limited to those who travelled to Cuba. Some activist

and graphic design organizations in the United States made reproductions of Cuban posters, often publishing or exhibiting them with translations and explanatory texts in order to make these objects legible to Anglophone audiences.

The Canadian paradigm differs somewhat from that of the United States. Canadian Prime Minister John Diefenbaker maintained diplomatic relations with Cuba following the Cuban Revolution in 1959. On the whole, Cuba-Canada relations remained amicable throughout the latter half of the 20th century in part through Canadian efforts to establish a foreign policy that was independent of U.S. American influence. Because of this, Canadian citizens were not legally limited in their capacity to visit Cuba, nor subject to the same import restrictions as U.S. citizens. However, unlike U.S. institutions, Canadian galleries and museums did not endeavour to collect Cuban posters. The circulation of Cuban posters in Canada is rather at the level of individual collecting and occasional commercial dealing.

What do gringos want with Cuban posters, anyway?

In my experience speaking with North Americans about Cuban posters, there is a genuine desire to understand Cuba's revolutionary history. From the PhD candidate who proudly displayed a Cuban screenprint on his office wall, to the young paramedic who wanted my opinion on her acquisitions from a trip to Havana, these casual collectors spoke of my homeland and its graphics with warm curiosity. U.S. American historian Louis A. Pérez Jr argues that metaphorical representation has informed and mediated U.S. American engagement with Cuba since the 1850s. The 1959 revolution made Cuba incomprehensible in the United States by rendering the images and metaphors through which U.S. Americans had come to know Cuba incompatible with the island nation's new reality. In brief, Pérez argues, "old metaphors no longer worked."[18] This dynamic arguably extends to Canadians as well. For those North Americans seeking to understand Cuba beyond the hegemonic anti-communist discourse, Cuban revolutionary posters provided a novel lexicon of images with which to make

[18] Louis A. Pérez, "Shifting Metaphors, Changing Meanings: Representing Revolution," in *Cuba in the American Imagination: Metaphor and the Imperial Ethos* (Chapel Hill: The University of North Carolina Press, 2008).

sense of post-1959 Cuba. The emergence of the New Left –a broad political movement invested in struggles for social justice and political and civil rights in the United States– in the late 1960s invigorated North American interest in Cuba. New Leftists were especially attentive to the Cuban Revolution and its unfolding socialist experiment. At the heart of this interest was a desire to understand Cuba as a testing ground for novel political possibilities in a time of certain political disillusionment at home. This stance of curiosity continues to colour North American perceptions of Cuba today. Yet, coupled with the fellow traveller's desire to understand is the collector's will to possess. It is not enough to witness a historical image when one can, for a reasonable price, own a part of history. Whether as socialist ephemera, as colourful mementos, or as art historical relics, North Americans insist on collecting Cuban posters. The Cuban revolutionary poster has come to circulate in North America in three key modes: as collectible, as political souvenir, and as reproduction.

Collecting Cuba: The Poster as Public Diplomacy

Public diplomacy, or people's diplomacy, spans a range of strategies that aim to influence foreign public opinion. Effective public diplomacy requires the collaboration of state and nonstate actors, and blends belief and persuasion to shape public opinion through explicit and implicit messaging. Revolutionary posters constitute tools of Cuban public diplomacy insofar as they historically influenced foreigners' beliefs and opinions about Cuba. Cuban-produced information materials appealed to those North American consumers who were disillusioned with hegemonic U.S. narratives of Cuba. The emergence of independent and institutional collections of Cuban posters in the U.S. of the 1970s evidenced interest and receptiveness to this form of Cuban public diplomacy.

U.S. American media scholar Jonathan Buchsbaum notes that critics of mainstream coverage of the U.S. war of aggression in Vietnam identified a credibility gap between information conveyed by the government and corporate media, and what they perceived as truth and lived experience.[19] This dissonance led some North Americans to seek out information about current events through alternative, independent, and foreign media. This phenomenon was not restricted to coverage of the war and explains, in part, why North Americans sought to learn about revolutionary Cuba from Cuban sources, particularly

following the U.S. embargo. In keeping with Pérez's observation that old metaphors no longer worked to understand Cuba, the conditions that led to diplomatic rupture between Cuba and the United States in the 1960s also contributed to widespread North American interest in Cuba. Cuban posters filled a demand for information about Cuba in North America that went beyond hegemonic mass media and U.S. state discourse. This context shaped institutional and personal collecting.

Between 1969 and 1974, the U.S. Department of the Treasury issued special licenses for the purchase of Cuban publications, including posters, by universities and libraries for research purposes. Growing interest in and access to Cuban materials implicated shifts in the collecting activities of U.S. American institutions, such that from April 13 to 15, 1970, the Library of Congress (LOC) hosted a series of workshops on collecting and managing Cuban materials: the International Conference on Cuban Acquisitions and Bibliography. The two-page LOC report on materials in the Prints and Photographs Division specifically lists "three series of propaganda pictures of the present day regime" and "twelve Cuban posters," though it is unclear whether the latter postdate the revolution.[20]

The Library of Congress was not alone in collecting Cuban graphics. The 1970s saw the rise and institutionalization of Cuban studies and its associated archives in the United States. For instance, the bilingual Cuban Studies Newsletter/Boletín de Estudios sobre Cuba was founded at the University of Pittsburgh in 1970, followed by the Center for Cuban Studies in New York in 1972. Both initiatives sought to advance Cuban studies and build resource collections.

In July of 1974, the Nixon administration authorized travel to Cuba for U.S. scholars for the purposes of study and research. This period of relatively relaxed travel and trade restrictions made it possible for individuals and cultural institutions other than universities and libraries to acquire and present Cuban posters without incurring the legal risks of the earlier trade and travel bans.

[19] Jonathan Buchsbaum, "Militant Third World Film Distribution in the United States, 1970-1980," *Canadian Journal of Film Studies 24*, no. 2 (Fall 2015): 51–65.
[20] Alan Fern, "Prints and Photographs" in Earl Pariseau, "Cuban Acquisitions and Bibliography. Proceedings and Working Papers of an International Conference Held at the Library of Congress, April 13-15, 1970." (Washington, D.C., 1970).

Private collections of Cuban posters similarly flourished in this period. Sam L. Slick, a professor of Spanish at Sam Houston State University, founded the International Archives of Latin American Political Posters (IALAPP) in 1976, which held a substantial number of contemporaneous Cuban posters he had begun privately collecting in the early 1970s. Slick collected posters as teaching tools to enliven his classroom, meaning he likely showed them to his students. While the collection records do not document student responses to Cuban posters, the fact that Slick describes using them to "spark students' interest" indicates enthusiasm for their form, if not their content explicitly.

For both institutions and individuals, there was a drive to collect and consume representations of Cuba by Cubans in order to supplement what they perceived as limited access to credible information about Cuba. But how did these posters serve Cuban public diplomacy? Buchsbaum's discussion of U.S. reception of Cuban films *Lucía* (1968, dir. Humberto Solás) and *Memories of Underdevelopment* (1968, dir. Tomás Gutiérrez Alea) in the 1970s highlights cultural products' capacity to challenge hegemonic views of Cuba. "By [showing] a Cuba able to grapple with contemporary domestic tensions through sophisticated artistic discourse," he argues, these works unsettle the image of Cuba projected by the U.S. government. The artistic accomplishment of these films made them into "impressive ambassadors at least for the richness of cultural life in revolutionary Cuba." This logic similarly extends to critically-acclaimed Cuban posters. Cuban revolutionary leaders and artists largely rejected the notion of a prescribed state style in the vein of socialist realism. Fidel Castro famously declared: "Our enemies are capitalists and imperialists, not abstract art."[21] Testimonies of U.S. visitors to Cuba consistently point to the avant-garde aesthetics of Cuban posters as well-received signifiers of the Revolution's progressive ethos.

The aesthetic features of these posters –which often

[21] "Nuestros enemigos son los capitalistas y los imperialistas, no el arte abstracto." Eva Cockcroft, "Cuban Poster," in *Cuban Poster Art: 1961-1982* (New York City, NY: Westbeth Gallery, 1983), cited in David Craven, "The Visual Arts since the Cuban Revolution," *Third Text* 6, no. 20 (September 1, 1992): 77–102. In his 1965 essay, *El socialismo y el hombre en Cuba* (Socialism and Man in Cuba), Guevara similarly rejected the Stalinist doctrine of Socialist Realism. Ernesto Guevara, "Socialism and Man in Cuba (1965)," *in Contemporary Latin American Social and Political Thought: An Anthology*, by Iván Márquez (Lanham, MD: Rowman & Littlefield, 2008).

adopted elements of Pop Art, Op Art, Minimalism, and other contemporary art movements– made them legible to young North Americans. Take, for instance, Raúl Martínez' 1968 poster for the film *Lucía* (fig. 1). The image functions within a Pop Art register, using a saturated colour scheme, large flat areas of colour, and dense black outlines to delineate objects from ground. Three close-up portraits dominate the composition. In keeping with Pop Art's interest in reproducing popular media, these portraits are based on film stills. The portraits are abstracted enough to obscure the actresses' likeness, and effectively render the women as icons. An energetic pattern of curving green and blue stripes connects the three portraits. Superimposed on these stripes are three flowers and a single five-pointed star which recalls the Cuban flag. This poster conveys a nationalist vision of Cuban socialist femininity that is easily legible as an attractive celebratory image to a foreign viewer. Cuban revolutionary posters' eclectic use of avant-garde visual language directly challenged hegemonic views of life on the island as repressed under totalitarian rule. Moreover, they illustrated a rich and expansive vision of cultural life in a socialist state. Together, these factors made posters such as Martínez' *Lucía* (fig. 1) effective tools of public diplomacy by allowing Cuban artists to represent the nation to foreign viewers through a shared avant-garde visual vocabulary. Visually appealing, politically resonant, and inexpensive, Cuban posters readily became a commodity for North American travellers.

From Cuba with Love: The Poster as Political Souvenir

Political tourism is an affective cultural practice where travellers seek to manifest solidarity with or participate in a political struggle taking place elsewhere in the world. Political tourists cultivate attachment, identities, and commitments that extend beyond their cultural boundaries. Through travel writing and collecting, political tourists record their processes of identification and political commitment within cross-cultural contact. Tourists' collection and archive-building activities provide insight into their views and values. In this sense, North Americans political tourists' description, documentation, and collection of Cuban posters speak to the meanings these images held for them. While even political tourists to Cuba were diverse in their backgrounds and motives, I am personally interested in the experiences of two groups: young activists and cultural workers (exemplified here in the travel narratives of early members of the Venceremos Brigade from 1969 to

1971, and members of the first delegation of African-American cultural workers to visit Cuba in 1976, respectively.)

In the summer of 1969, a group U.S. American self-described radical activists drawn from various leftist organizations convened to found the Venceremos Brigade. This organization aimed to contribute to the Cuban Revolution through direct volunteer participation, often in the form of physical labour. The first Venceremos Brigade left for Cuba via Mexico in late November of 1969 and returned via Canada in February of 1970. The unit was composed of 216 volunteers, including women and men and racialized and white brigadistas. Volunteers worked as cane cutters for six weeks, then toured Cuba for two weeks. Subsequent groups followed.

In 1971, U.S. American publisher Simon & Schuster published a compilation of interviews, testimonies, and letters by members of the Venceremos Brigade.[22] These texts provide insight into the experiences and impressions of the brigadistas as political tourists to Cuba, and touch on a wide range of subjects. Writing on North American and Cuban political art, brigadista Peter Constanza laments the prosaicness of the former, noting "Cuban posters, with their yellows, fluorescent blues, greens, and colours I've never seen are amazing: psychedelic struggle." Brigadista Karen Duncan similarly notes: "Cuban graphics are out of sight!... Cuba is like having the underground newspapers overground." These comments illustrate brigadistas' perceptions of Cuban posters as formally and ideologically appealing. In addition to travel testimonies, this 1971 anthology also engages in a form of Cuban poster dissemination. Among the images of revolutionary Cuba and photographs of the brigadistas at work included in the book, four are direct black-and-white miniaturized reproductions of Cuban posters on the subjects of Cubanness, the Vietnam War, and Che Guevara.

My own recent conversation with San Francisco based Chicano graphic artist Juan R. Fuentes, who travelled to Cuba with the Venceremos Brigade in 1974, reiterates the ubiquity of Cuban posters in the travel experiences of brigadistas. Fuentes casually noted having picked up posters and an issue of OSPAAAL's *Tricontinental* magazine while in Havana. He spoke

[22] Venceremos Brigade, *Venceremos Brigade: Young Americans Sharing the Life and Work of Revolutionary Cuba: Diaries, Letters, Interviews, Tapes, Essays, Poetry, by the Venceremos Brigade*, ed. Sandra Levinson and Carol Brightman (New York: Simon and Schuster, 1971).

of being struck by the flat bold style of Cuban poster designers like René Mederos, and of its influence on his own graphic work in the 1970s.

Two articles in the summer 1977 issue of *The Black Scholar* –a San Francisco-based journal of Black studies and research founded in 1969– narrate the experiences of members of the first delegation of African-American cultural workers to visit Cuba in partnership with the Cuban Institute for Friendship with the Peoples (Instituto Cubano de Amistad con los Pueblos, or ICAP) in November of 1976. Distinguished African-American printmaker and art historian Samella Lewis describes the ubiquity and state support for print workshops.[23] Two of the six captioned photographs embedded in her article centrally feature Cuban posters, including "a recent poster from the workshop of the Central Committee of the Communist Party." Lewis notes that "some visual artists work as members of a team and are responsible for the production of propaganda posters" and "are free to do their own private work." She praises the youngest generation of Cuban artists as active innovators who "have elevated printmaking in Cuba to a premier art form and have produced a public art that conceptualizes the highest form of public concern." These descriptions of posters and artists' working conditions highlight favourable views of artists' autonomy in Cuba and attribute aesthetic and political potency to Cuban graphics. Lewis's article illustrates the ubiquity of revolutionary posters in political tourism to Cuba and underscores that documenting and disseminating these posters to North American readers was one of the functions of political tourism narratives.

African-American poet and literary scholar Robert Chrisman, a member of the same 1976 delegation to Cuba, also discusses posters in his account of the visit.[24] Chrisman remarks on the use of Cuban posters to cement international solidarity. He notes that "solidarity also included support of our own Black struggle in the United States" shown at the mass level in posters and billboards. Chrisman interviews Enrique Vignier, then Director of leading Cuban art journal *Revolución y Cultura,* about Cuban graphics. The author frames their discussion through questions of what was being done to promote "the

[23] Samella Lewis, "Art and Artists in Cuba," *The Black Scholar 8*, no. 8/9/10 (1977): 12–15.
[24] Robert Chrisman, "National Culture in Revolutionary Cuba," *The Black Scholar 8*, no. 8/9/10 (1977): 2–96.

development of a militant visual art ...that was public and accessible." Like those of the brigadistas, the travel narratives of cultural workers articulated the centrality of posters in Cuban revolutionary visual culture.

Though these tourist narratives do not always explicitly name poster collecting, oral histories of this time indicate that travellers would have typically acquired Cuban posters and brought them home to the United States. For North American political tourists, posters mediated and memorialized their experiences of revolutionary Cuba. The writings of brigadistas such as Constanza and Duncan, and of artist-activists such as Lewis and Chrisman indicate that political tourists were receptive to ideas of creative autonomy, democratization and politicization of visual arts, and internationalist solidarity embedded in the production processes and content of Cuban revolutionary posters.

Political tourism functions within broader realms of tourism and leisure travel. Those North Americans visitors to Cuba who were not motivated by political commitment would have adopted more apathetic stances on the revolutionary messaging of these posters. This detachment created space for reproduction devoid of context, visual cooptation, and broadly depoliticized engagement with Cuban revolutionary graphics.

Reproduction & Co-optation: The Cuban Poster as Aesthetic Object

Cuban posters make appearances in unexpected places: on a wall of the Institut d'Études Politiques in Paris in a 1968 photograph by Bruno Barbey, behind a curator's desk at the National Museum of (U.S.) American History in Washington, D.C. in 2018, on the covers of history books and exhibition catalogues, and countless others. The modes of North American engagement with Cuban posters discussed so far attend to the persuasive function of these images. Yet every reproduction exists within some distance of its original's uses and meanings. What about uses of Cuban posters that are ambivalent or indifferent to their political function? In the case of Cuban posters in North America, decontextualization and reproduction popularize these images while broadening possibilities for more ambiguous and apathetic readings. In this sense, the continued circulation of Cuban posters in North America signifies a complicated mixture of commitment to revolutionary politics and aesthetic co-optation.

U.S. American archivist Lincoln Cushing, who has long championed the preservation and stewardship of Cuban revolutionary posters, notes that many of the images in Cuban posters have been formally and informally reproduced in U.S. posters. He cites examples such as Glad Day Press' 1971 poster for the Vietnam solidarity movement, and Berkeley's Inkworks Press and the Fireworks Graphics Collective donating use of their facilities to reprint an OSPAAAL poster. Other organizations, such as the self-identified feminist, radical, and anti-capitalist Chicago Women's Graphics Collective (1969-77), have also reproduced Cuban posters that aligned with their values. For instance, their 1975 silkscreen poster for International Women's Day directly reproduces Clara Díaz Díaz's 1974 print (fig. 2.0) on the same subject for the Federation of Cuban Women, slightly modifying composition to accommodate translations of the text into English, and lightening the skin tone of the leftmost figure (fig. 2.1). The 1975 poster notes that the design is a reprint from a Cuban poster, but does not name Clara Díaz Díaz as the designer. As of 2021, the Chicago Women's Liberation Union's Herstory Project lists a contemporary reprint of Clara Díaz Díaz's poster (fig. 2.2) on their webstore, where a large (13x19-inch) reproduction on archival paper is listed for 25 USD.

The degree to which these reproductions credit the original designs and their makers varies, but it is crucial to avoid evaluating reproduction through contemporary notions of copyright. For the bulk of the 1960s, Cuban artists working on poster design in all three agencies did not sign their work; authorship was generally secondary to articulating a message effectively. Moreover, the Cuban state itself did not strictly observe copyright law. For instance, the Book Institute (Instituto Cubano del Libro, or ICL, f. 1967), a national press, periodically purchased and reproduced foreign books en masse without licensing agreements. Cuban poster artists and publishers of the 1960s were largely concerned with limiting the reproduction of their work abroad, particularly when these reproductions served to disseminate the original revolutionary message. Yet, this was not the case for all poster reproductions.

Before I was able to travel to archives in Cuba, my very first haptic encounter with Cuban posters was through a North American book of reproductions, on interlibrary loan from UC Berkeley at the University of Alberta in early 2016. In 1970, publisher McGraw-Hill partnered with illustrator Dugald Stermer to produce the first U.S. American book on Cuban posters: an English-language compilation of 96 reproductions of Cuban

revolutionary posters in an oversized book titled *The Art of Revolution* (Fig. 1), with an introductory essay by Susan Sontag.[25] I recall leafing through the pages of this tome: full-colour images of ICAIC and OSPAAAL posters on uncoated, lightly yellowing paper. Not quite to scale, but large enough to warrant a desk. Very near, I thought, to the real thing. On the book's cover was a version of Alfredo Rostgaard's *Canción Protesta* poster (1967), a single iconic long-stemmed rose with two thorns, modified to fit the book's title and author names.

In her introductory essay to this tome, Sontag critically notes the growing popularity of Cuban posters among a particular subset of the population she characterizes as the "educated young bourgeoisie of America." She warns readers that they "should not feel altogether comfortable" with the effect of removing posters from their original functional context, which she terms a "tacit betrayal." Capitalism, Sontag argues, "transforms all objects, including art, into commodities. And the poster –including the revolutionary poster– is hardly exempt from this iron rule of co-option." The incongruity of writing this in the foreword of a commercial volume of poster reproductions is not lost on the author. Sontag left me to sit with the tension of my complicity in the images' co-optation.

The production of this book of reproductions by a commercial publisher evinces a degree of popular, or at least bourgeois, interest in Cuban posters as aesthetically valuable objects that is curiously distinct from the material objects themselves. What then, does the form of *The Art of Revolution* reveal about its intended consumers? Showing ninety-six different posters in full colour and generous scale, *The Art of Revolution* was a resource at a time when digital reproduction technology was still decades away. Whether as a conscious choice or a matter of logistical constraints, the book maintains a minimal approach to situating the images. Designs are presented side-by-side with no metadata or contextual information. As a bound tome of miniaturized images, *The Art of Revolution* visually signals a containment not altogether different from the United States' historic approach to Cuba. Nestled between the book's covers, the posters are no longer public images. Rather, they become objects of a quieter, slower, individualized visual consumption. This reduced scale makes viewing posters the purview of a

[25] Dugald Stermer and Susan Sontag, *The Art of Revolution*, 1st ed. (New York: McGraw-Hill, 1970).

single, privileged observer. In this format, images designed as visual shouts on the wall, meant to clamour for attention against the steady beat of life on a busy street corner, could be coolly set down, stored away, and ignored at will. *The Art of Revolution*, I argue, allowed North American readers of the 1970s to engage with Cuban posters as purely aesthetic objects through various degrees of abstraction: without coming into contact with the original objects, having to travel to Cuba or to engage with the political context of the images.

While the existence of *The Art of Revolution* does not threaten archival access to Cuban posters in Cuba, it does effectively illustrate the paradigm of commodification that has fueled North American collecting of these objects.

Closing Notes

Cuban revolutionary posters have circulated in the United States and Canada since the 1970s through private and public collections, reproductions, and travel narratives. They held and continue to hold a multitude of intersecting meanings for North American viewers that span the realms of public diplomacy, tourism, and design history. Though sustained exposure and a drastic reduction in poster production in Cuba since the late 1980s have made these graphics less salient to North American viewers, they continue to enjoy circulation in private and public collections. Recent exhibitions of Cuban posters in Los Angeles (2017), Washington, D.C. (2017), Minneapolis (2017–18), and Pasadena (2018) attest to their enduring appeal.

My most recent encounter with Cuban posters, this time in Canada, was at the Montreal Museum of Fine Arts (MMFA) in early March 2020 on an archive visit generously hosted by Dr. Erell Hubert, Curator of the Arts of the Americas. The MMFA holds a modest collection of Cuban revolutionary graphics, many of which were acquired after the museum hosted *¡Cuba! Art and History from 1868 to Today*, the largest exhibition of Cuban art ever presented outside the country, in 2008. The collection includes a poster series by Felix Beltrán titled *Otras manos empuñarán las armas* and published by the ICAP after Che Guevara's assasination in 1967, and a ten-print series modelling billboard designs for the Ten Million Ton sugarcane harvest of 1970. These brief descriptions already surpass the MMFA archive's metadata for these objects.

The posters are evidently well cared for. Archival paper lines

each object. They are permanently stored in their designated stainless steel drawers in a climate-controlled room at the core of a labyrinthine facility. As a Canadian researcher, I know that if I produce the necessary justification and adhere to the proper protocol, I can count on the certainty of access to these objects. For this, and for the care, I am grateful. Another part of me wonders if a Cuban researcher would find this arrangement equally convenient. Another still wonders when these objects were last seen by human eyes.

The presence of Cuban posters in collections across North America contrasts their scarcity in Cuban archives. Thinking back to the state of the poster collection at the José Martí National Library in Havana, my frustration persists. Digitization and web publishing offer possibilities for disseminating and engaging with Cuban revolutionary posters, but as long as internet access remains prohibitive to Cubans, digital options will remain grossly inadequate. What does the northward migration of revolutionary posters mean for Cubans nationals and scholars of Cuban visual culture?

In framing this paradigm, I do not mean to lament naïvely. Cultural matters fall by the wayside in the face of more pressing material concerns: posters are secondary to human welfare. I mean simply to point out that these cultural objects, like people, follow capital, and that this mobility has consequences for how social, political, and cultural histories of Cuba can be told at home and abroad. Cuban posters in North American archives are not the Parthenon Marbles at the British Museum. Their story is not reducible to a narrative of imperialism, though U.S. imperialism certainly plays a part. Yet these objects, however humble, bear the capacity to relate histories that should rightfully remain accessible to the people that produced them.

Fig. 1.

Raúl Martínez, ICAIC. *Lucía* (1968) Silkscreen print; 76.2 cm x 50.9 cm. José Martí National Library. Havana, Cuba. Courtesy of the BNJM.

Figure 2.0.

Estela Díaz Díaz. *Marzo 8 Día Internacional De La Mujer*, 1974. Silkscreen on paper, 71 cm x 52 cm. José Martí National Library, Havana, Cuba. Courtesy of the BNJM.

Figure 2.1.

Chicago Women's Graphics Collective. *Día Internacional De La Mujer / International Women's Day*, 1975. Silkscreen on paper, 71.75 cm x 50.80 cm. Courtesy of the author.

Figure 2.2.

Chicago Women's Liberation Union. *Día Internacional De La Mujer / International Women's Day*, n.d. Digital Image. Courtesy of the Chicago Women's Liberation Union Herstory Project, www.cwluherstory.org.

Figure 3.

Cover and colophon pages of 1st Pall Mall Press edition of Dugald Stermer and Susan Sontag's *The Art of Revolution*, 1970. Softback portfolio, 34.2 cm × 45 cm. Courtesy of the author.

Bettina Pérez Martínez
Puerto Rico

Bettina Pérez Martínez is a curator. She holds an MA in Art History from Concordia University in Montreal, a BFA in Printmaking, and a BA in Art History from the State University of New York, Purchase, New York. Her research interests focus on Latin American and Caribbean 20th and 21st Century art and their relation to political and social issues, as well as environmental issues. She also explores the identity of former and currently colonized countries within the Caribbean.

Seascape Poetics: Digital Diasporas in World Making

> *Our landscape is its own monument: its meaning can only be traced on the underside. It is all history.*
>
> Edouard Glissant, "Caribbean Discourse" (1989)

When I moved to Montréal from Puerto Rico in August 2017 I had little clue about Montréal's engagement with contemporary Caribbean visual artists in its galleries and art spaces: I admit I enthusiastically lunged at the opportunity of beginning a master's degree in Montréal without proper study of the recognition (or lack thereof) of contemporary Caribbean artists had in Canada. Upon arriving I observed how, although the Caribbean is a common tourist destination for many Canadians, the region is conceptualized as a space of neocolonial consumption and there is little interest in engaging with people from the Caribbean outside of this framework. Further, my interest in studying the Caribbean and its contemporary art production during my degree was considered very niche and out of the ordinary by the Canadian academic institutions where I worked. This situation sparked my determination to curate *Seascape Poetics*, a digital exhibition hosted virtually by 4th Space and the Curating and Public Scholarship Lab (CaPSL) at Concordia University from February 12 to February 26, 2021.

My decision to create an exhibition examining Caribbean relationships was strengthened by the extreme climatological events of September 2017, when the Caribbean faced one of its most active and dangerous hurricane seasons in recent history. Within weeks of each other, three category-five hurricanes (named Irma, María and José) struck the Caribbean, causing irreparable and enduring damage in the region. Living this experience from the diaspora took an emotional toll on me. During those days it became apparent to me that, despite the difficulty and pain rooted in this experience, I wanted to convince people of the need to address contemporary Caribbean art as a way to understand and place into a Canadian context the colonial, racial, ecological struggles the region currently faces. In Canada, the hardships faced by Caribbean nations are invisibilized through strategies of exotification at the service of tourism marketing, as many Canadians tend to reduce the region to a vacation destination.

During the pandemic, the conceptualization of the Caribbean was expanded by Canadian media to include exotic work locations. In July 2020 the CBC published an article titled "Sick of working from home during COVID? Do it from Barbados, island nation tells pandemic-weary Canadians." As a result, travel to the Caribbean from Canada increased, endangering the lives of the local populations.

These experiences influenced the exhibition goal of *Seascape Poetics*, namely, to mobilize an ecocritical lens through which to examine archipelagic identity in the Caribbean region while focusing on four key concepts: tropicalization, tidalectics, poetics of landscape, and diaspora.

Curatorial Approach

Seascape Poetics was developed during a 10-month curatorial residency created by the Beyond Museum Walls collective, which is part of Concordia University's Curating and Public Scholarship Lab, a program that focuses on creating exhibitions and public dialogues in response to critical social issues. The original residency proposal I presented in 2019 entailed recreating an immersive, in-person installation of *Between Us Two* by Puerto Rican artist Lionel Cruet, exploring themes of climate change, ecology, and colonialism in Puerto Rico. As a result of the pandemic, however, I had to pivot and re-imagine the exhibition into a format that was better able to deal with related social limitations: a completely digital model.

Developing an online based exhibition had significant challenges, not the least of which was my own lack of familiarity with creating these spaces. Throughout the residency, I worked closely with a web development team and collaborated with participating artists to avoid tropicalizing tropes common to tourism advertising, such as barren white-sand-and-blue-water beaches depicted during sunset or high noon. Instead, *Seascape Poetics* was set at dawn in an effort to invoke a space of transition and liminality, alluding to the "ebbs and flows" Barbadian poet Kamau Brathwaite (2006 International Winner of the Griffin Poetry Prize) described in his theory of tidalectics.

The chosen title for *Seascape Poetics* is also deeply embedded in tidalectics, a concept that explores an "alter/native" history contesting linear models of colonial progress, as well as an "alter/native" epistemology to Western colonial practices.

The term emerged from Braithwaite's exploration of "tidal dialectics," which refers to German philosopher's G.W.F. Hegel's dialectic methodology, while exploring this cyclical model through the ocean's continual movement and the rhythm of the sea. Through the focus on tidalectics, *Seascape Poetics* sought to honor the nuances and diversity of each island-nation alongside the archipelagic connections they share, through a rhythmic understanding of our histories, identities, and experiences. Brathwaite's concept proved crucial to the creation of *Seascape Poetics* as it provided a framework through which to examine the complexity of Caribbean relationships to water and seascapes. By establishing a direct relationship between Caribbean histories and communities with fluidity, *Seascape Poetics* aimed to represent archipelagic identity in relation to an ecologically-informed perspective.

Although web development became an essential tool in recreating an immersive experience online, the theoretical component of digital place-making was equally important to me during the articulation of the exhibition. I wanted *Seascape Poetics* to become a space through which the Caribbean and its diaspora could seamlessly connect, and where Caribbean artists, theorists, curators and researchers could come together regardless of their geographical location. This focus allowed the exhibition to create relational connections unhindered by the physical boundaries of the global pandemic.

The concept of archipelagic relationships was also key to the creation of *Seascape Poetics*. First articulated by Martinician poet Édouard Glissant through his theories of Poetics of Relation and rooted in rhizomatic thought, archipelagic relationships in the Caribbean were defined as paradigms "…in which each and every identity is extended through a relationship with the Other."[26]

The ecocritical position of *Seascape Poetics*, informed by my experience of the September 2017 superstorms mentioned earlier, allowed me to observe Glissant's adaptation of the term poetics of landscape where he emphasizes the inextricable bonds Caribbean communities have with the land/seascape they share: "the individual, the community and the land are inextricable in the process of creating history. Landscape is

[26] Glissant, Édouard. 1997. *Poetics of Relation.* Translated by Wing Betsy. Michigan,: University of Michigan Press.

a character in this process. Its deepest meanings need to be understood."[27]

Drawing from tropicalization, a concept developed by art historian Krista Thompson in her text "An Eye for the Tropics: Tourism, Photography, and Framing the Caribbean Picturesque," *Seascape Poetics* also aimed to examine the tourism industry in the Caribbean through visual representation and culture. As defined by Thompson, tropicalization "describes the complex visual systems through which the islands were imaged for tourist consumption and the social and political implications of these representations on actual physical space on the islands and their inhabitants." Through the utilization of this concept, *Seascape Poetics* sought to challenge Canadian media depictions of the Caribbean, which often exotify the region as a tropical paradise meant for avoiding the cold Canadian winters.

Throughout the creation of the digital environment of *Seascape Poetics*, I was careful to avoid tropicalization and consciously discussed strategies to subvert this exoticizing trope with participating artists and members of the web development team. When recreating the shoreline depicted in *Seascape Poetics*, for example, I visualized the idea of recreating a Caribbean ecotone, where different ecosystems converge and interact with one another, as a way to highlight the liminality of the shoreline. Liminality and convergence became increasingly frequent strategies in the exhibition development as these concepts encapsulated ecocritical perspectives of interdependent ecosystems and non-hierarchical interactions between human and non-human entities.

Digital Diaspora

Being situated online, *Seascape Poetics* was able to feature work and public programming by artists from the Caribbean both residing in the region and its diaspora. Utilizing the exhibition's virtual recreation of a Caribbean land/seascape, the region and its diaspora could coexist within a digital space: a digital diaspora. The concept of digital diaspora, coined by curator Legacy Russel in 2013 and expanded in her book

[27] Glissant, Édouard. 1999. "Cross-Cultural Poetics" in *Caribbean Discourse: Selected Essays*. Translated by J. Michael Dash. Charlottesville: University of Virginia Press.

Glitch Feminism (2020), means that "bodies in this era of visual culture have no single destination, but rather take on distributed nature, fluidly occupying many beings, many places, all at once." On the other hand, Professor of Media, Gender, and Postcolonial Studies at Utrecht University, Sandra Ponzanesi, argued in her essay titled "Digital Diasporas: Postcoloniality, Media, and Affect" (2020), that the term digital diaspora lacks a clear definition and therefore it allows for flexibility in its functional conceptualization. Ponzanesi further problematizes the notion of digital diasporas by indicating that there is still limited knowledge regarding the impact of digital diasporas on the formation of digital communities across the so-called Global South and Global North.

With *Seascape Poetics*, I sought to extend the fluidity of identity experienced in other digital diaspora spaces. Caribbean identity, because of the region's complex history with colonialism and neoliberalism, contains multitudes shaped by race, gender, and class. However, Caribbean identity should not be reduced to only these factors, as there is an often-ignored relationality in the region, expressed through its land/seascape. Taking into consideration Ponzeranesi's problematization of the digital diasporas, I consciously sought to not flatten *Seascape Poetics* by alluding to specific national identities, histories or socio-political conditions. Instead, I wanted to highlight similar experiences connected to land/seascape throughout the Caribbean region centered around the image of a beach in a cove -an image trope often used in the late 20th and early 21st centuries to commodify images of a Caribbean vacation. The beach in *Seascape Poetics* however, is not a beach that audience members may have seen before in tourism promotional material, but one that challenges the exotifying idyllic paradise tourism trope of the Caribbean, and subverts tropicalization through socio-politically and ecologically engaged artworks that address complex realities in the region.

Preliminary sketch of the graphic environment for Nadia Huggins' Transformations (2014) within the virtual exhibition *Seascape Poetics*. Courtesy of the author.

Still image from the immersive environment of *Seascape Poetics* featuring the work of Nadia Huggins. Courtesy of the author.

Still of title space in *Seascape Poetics*. Courtesy of the author.

Still from interactive environment of *Seascape Poetics*. Courtesy of the author.

This book was printed in Amiskwaciwâskahikan / Edmonton, Alberta in October 2021 by Priority Printing.